IMAGES
of America

DUBLIN

ON THE COVER: Taking a break from the hot afternoon sun in the shade offered by a hay wagon, a thresher crew poses for a photograph. Martin Stajohann is at far right. (Courtesy Dublin Heritage Center.)

IMAGES
of America

DUBLIN

Mike Lynch and
the Dublin Heritage Center

ARCADIA
PUBLISHING

Published by Arcadia Publishing
Charleston SC, Chicago IL, Portsmouth NH, San Francisco CA

Printed in the United States of America

Library of Congress Catalog Card Number: 2007922174

For all general information contact Arcadia Publishing at:
Telephone 843-853-2070
Fax 843-853-0044
E-mail sales@arcadiapublishing.com
For customer service and orders:
Toll-Free 1-888-313-2665

Visit us on the Internet at www.arcadiapublishing.com

*I would like to dedicate this book to my great-great-grandparents,
Michael and Mary Devany, for taking the biggest chance of their lives.
They willingly left their family, everything they knew, to make a new
beginning for themselves in a strange new land known as America. If
either of them lacked so great a courage, I would not be here today.*

CONTENTS

ACKNOWLEDGMENTS

I would like to extend my gratitude to all those people and organizations who responded to my phone calls, visits, and e-mails. I thank them for their support of this project and their willingness to share their photographs, memories, and family stories.

I would also like to offer my sincerest thanks to Elizabeth Isles, director of the Dublin Heritage Center. Without her help, guidance, and support, I could have never finished this book. She was indispensable in granting me unfettered access to every record at her disposal. Thank you, Elizabeth, for giving me this tremendous opportunity and entrusting to me so great a treasure. All photographs in this book without a credit line are courtesy of the Dublin Heritage Center.

To Mary Chervet at Pleasanton's Museum on Main Street, thank you. She opened the doors of the museum to me and allowed me direct access to their superb photographic collection. Many of the pictures in this book are here because of her.

I would also like to thank my neighbor and friend Mike Brogdon. His willingness to let me scan numerous batches of photographs and historic documents made such a monumental task far easier than it would have been otherwise.

For those who have come before me, I realize that much of what is contained within these pages would not exist without their years of research and diligence—people like Virginia Bennett Smith, Dick Finn, Anne Homan, and John and Marie Cronin. In a time when few people cared about preserving the past, they rescued many of the treasures we enjoy today. As a philosopher once said, "I can see a little farther because I stand on their shoulders."

To my wife, Kathleen, and my children, Bethany and Nathan, thank you for giving me the time needed to research and write this book. If it wasn't for your support and encouragement, I could never have been able to finish this project. Gratitude is a word that is not strong enough, but it will have to suffice.

INTRODUCTION

Say the name of Dublin and, for many, it conjures up an image of weary Irish pioneers who, after traveling thousands of miles along dusty byways of the California trail, stood on the crest of a hill overlooking a valley filled with promise and hope for the future. This was the place they would call home. Inspired by memories of the rolling green hills and wide-open countryside of their beloved Ireland, they chose a name that helped maintain their connection to a land that now lived only in their memories.

While it is tempting to embrace this romantic notion of Dublin's beginning as the way it really happened, as is often the case, the truth is far richer and more diverse than first realized. Dublin did indeed beckon many Irish to settle down in newly established California, but it did also for those from Spain, Denmark, Germany, Italy, and Mexico, just to name a few. From the beginning, Dublin stood in the crossroads; starting with trails used by Native Americans for thousands of years, to stagecoach routes traveled in the 1850s and 1860s, to modern-day freeways I-580 and I-680. Those who came and stayed, whether simple farmers or prosperous merchants, were drawn by a simple premise that if they worked hard, contributed to the betterment of society, and worshipped the God of their faith, they would find belonging, community, and prosperity. This, above all else, was the lure and promise of Dublin.

It is interesting to note that *Oakland Daily Evening Tribune* reporter W. P. Bartlett expressed many similar thoughts in an article about his travels through Murray Township in January 1887:

> The agricultural operations of the mission fathers had made well-known the richness of the valley lying along the shore of San Francisco Bay, and forming the greater portion of the western half of the new county [Alameda], and it is possible that more than one of the minds constituting that judicial body possessed some foresight of its future greatness. Covering 400 square miles . . . there are mountains higher than England can boast; land richer than that of Holland; scenery that reminds the Swiss of his mountain home; and a variety of resources exceeded by no other tract of similar size in this or any other country. What other 400 square miles of territory in California, or Europe for that matter, produces for export wheat, barley, hay, hops, wine, fruit, olives, wool, vegetables, berries, melons, cattle, sheep, hogs, poultry, eggs, wood, coal, chrome, magnesia, and manufactured goods that contain gold, silver, graphite and quicksilver? Yet with few exceptions, each of these now brings annually thousands of dollars to our people; and within a few years, not only will these few be bringing in their thousands, but many other articles will be added to the list.

If W. P. Bartlett happened upon Dublin today, one wonders if the city we now enjoy is the fulfillment of the town he envisioned back in 1887.

So just how did Dublin get its name? The simplest answer to this most basic of questions is that no one really knows. Even the most learned historians espouse diverse views about the name's origins. Perhaps the answer still lies in some yet-discovered document or newspaper clipping tucked away in a chest in someone's attic. Until this happens, if it ever does, we are left with a few tantalizing clues, offering a few brief hints as to how the name of Dublin came to be. In fact, it may even surprise you to learn that the city of Dublin has been known by four other names.

Anne Homan wrote extensively about this issue:

> In 1834 after retiring from the Mexican Army, Jose Maria Amador moved to his land grant of 21,000 acres, Rancho San Ramon; it extended from today's Dublin up through the San Ramon and Tassajara Valleys. In the same year he built a two-story Monterey-style adobe as his headquarters. The area became known as 'Amador's.' . . . In 1853 Amador sold 10,000 acres of his rancho, including his adobe, for $22,000 to James Witt Dougherty. West of the adobe site, Dougherty built a hotel on the north side of Dublin Boulevard that he called Dougherty Station. The area's name changed from Amador's to Dougherty's Station with the establishment of a post office in 1860. The name was shortened to Dougherty in 1896; on February 29, 1908, the name was changed to Dublin, probably because of the many Irish immigrants living there.

When tackling this issue on his Web site, "History Mysteries," Barry Schrader wrote, "The name Dublin popped up about 1878 in the Thompson and West atlas and soon became the name used by residents. Maybe many of them were from Ireland and they wanted a tie to the homeland?"

The 1867 Pacific Coast Business Directory contained names and post office addresses for professionals living in San Francisco and surrounding communities and, interestingly, Dublin was listed as their place of residence—for example: carriage and wagon manufacturer Paul Larsen (Dublin); express agent Peter Donlon (Dublin); Amador Valley Hotel (Dublin); harness and saddlery William McCully (Dublin); and merchant John Green (Dublin). When it mentioned the town listing, the 1867 business directory states, "Dublin, Alameda Co. (P. O. Box Dougherty Station) 18 miles southeast of San Leandro."

A newspaper article from the 1960s shares this anecdote:

> It is said that in the 1860s, a stranger who stopped at Dougherty's home asked the name of the stopping-place. Dougherty replied that while it was formerly known as Dougherty's Station by the postal department, that there were so many settlers of Irish extraction in the area around the town, that it should be properly called Dublin. This comment so amused the Irishmen in the area that they promptly dubbed the hamlet growing up at present day San Ramon, and then named Lynchville, as the town of Limerick. The road between became known as the Dublin-Limerick Road to Tipperary.

In 1883, M. W. Wood wrote biographies for many of Dublin's prominent settlers. When discussing the town's origin, this is what he had to say:

> It is not precisely known how this place got its name. We fail to find a stream running through its center answering to the Liffey of Ireland's capital. It is said that in this locality most of the early settlers hailed from the 'Green Ould Isle,' and thus the only two clusters of houses were respectively named Dublin and Limerick (San Ramon) by the facetious American, but, mutato nominee—the name being changed—the first is occasionally called by the possibly less Hibernian cognomen of Dougherty's Station!

Of note in this book, the section listing the town names, he settles on the name of Dublin and not Dougherty's Station.

Lastly, a curious article appeared in the *Livermore Herald* in February 1908 that sheds some light on this issue. "A new postal regulation will require the postmaster to spend two hours a day of actual personal time at every post office. Thomas Green, who has been postmaster at Dublin, which is known in official postal circles as Dougherty Station, refuses to comply . . . and has sent in his resignation. No one has been found who is willing to serve." The article went on, noting Thomas Green stated there were days when his work did not keep him busy for two hours. Deputy George Kolb would not take the job, so the mail had to be delivered on route from Hayward. On February 29, 1908, the "Dougherty" post office closed. The name of the town became Dublin at the exact same time, remaining so ever since.

So we see that through the years, various explanations and descriptions about the evolution of Dublin's name abound. In the end, the truth is no one really knows for sure. Perhaps one day the real reason might come to light, and we will know beyond a shadow of a doubt just how Dublin got its name.

One

TAMING THE WILDERNESS
PREHISTORY–1850

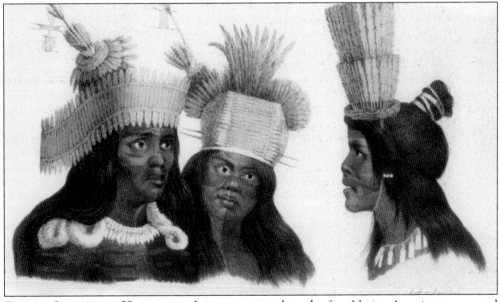

OHLONE INDIANS IN HEADDRESS. It is uncertain when the first Native Americans appeared in the greater Bay Area, but radiocarbon dating suggests as early as 5,000 years ago. Unlike other Native American tribes throughout the United States, the Ohlones lived in small family groups or in villages. There is also evidence they practiced horticulture, hunted local game, and developed complex social structures. The first Spaniards to see the Amador Valley were with the Fages Expedition in 1772. Fages and his men entered the valley as they were returning from an expedition to find a route to Drakes Bay. The party watered their horses at well-known watering holes, one of which was probably Alamilla Springs in Dublin. With the coming of the missions, specifically Mission San Jose in 1797, the Spaniards established the chief trading center and administrative outpost for the area.

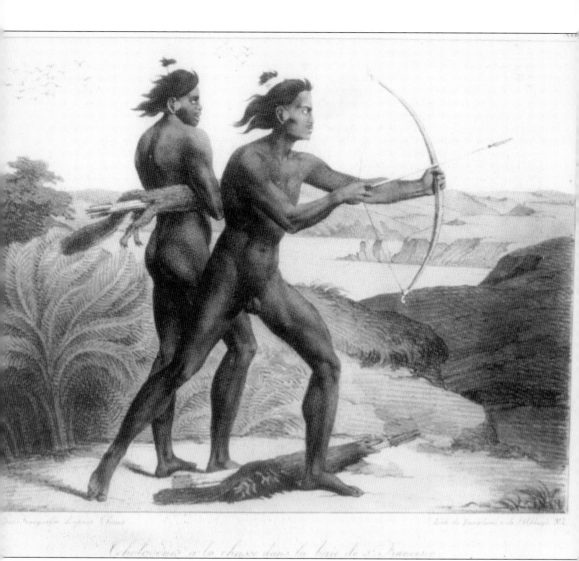

OHLONE INDIANS WHILE HUNTING. Spanish fathers viewed the California Native Americans as lost children, incapable of understanding beyond a simple level. Further, they saw them as lost souls, doomed to eternal suffering unless converted and baptized. The priests were appalled to see nearly naked Native Americans, smeared with mud to keep out the cold, living on acorn mush in huts made of reeds. Their plan was to clothe the Native Americans and teach them to weave cloth, to improve their diet, and to raise beans, corn, and fruit. They also taught them the importance of building permanent houses with adobe bricks. This plan would take about 10 years, the padres calculated, and then the Christianized Native Americans would settle their families on small farms, effectively colonizing California.

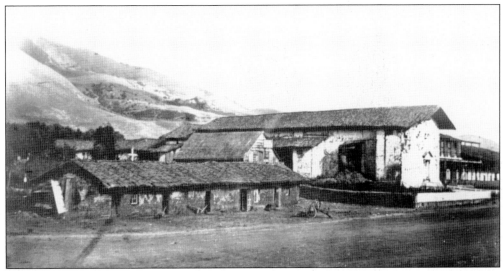

MISSION SAN JOSE DAGUERREOTYPE TAKEN IN 1852. Fr. Fermin Lasuen founded Mission San Jose on June 11, 1797. With the establishment of a permanent Spanish settlement, life for the Ohlones would never be the same. Hundreds of Native Americans came to live and work at the mission, which became the center of their religious, education, social, and economic lives. They erected adobe buildings, and they learned to make clothes, shoes, tools, and ropes. Mission San Jose baptized more Native Americans than any other mission, having their population peak around 1,900. Over the next two decades, the mission system faced a gradual period of decline. By 1834, the Spanish missions became secularized. In 1868, a 7.0-magnitude earthquake along the Hayward Fault struck the area, destroying most of the church.

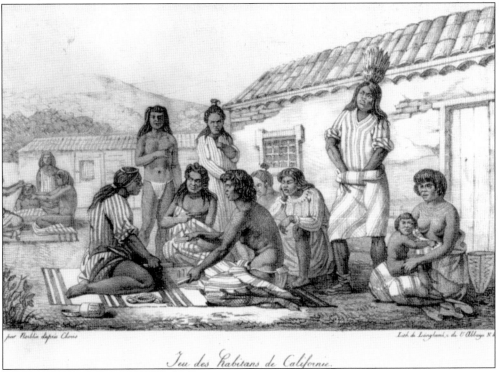

JOSE MARIA AMADOR (1781–1883). The secularization of California missions from 1834 to 1837 opened great amounts of land throughout California for grants. One of those to whom land was given was Jose Maria Amador. Born in San Francisco in 1781, he served as a private in the Spanish army from 1810 to 1827. After his discharge, he became the mayordomo at Mission San Jose, holding the post until 1835. His years of service as a soldier and administrator merited him a grant of four leagues (a league being 4,400 acres) of mission land in 1835. He called it Rancho San Ramon. As the years passed, Amador eventually sold off all of his vast holdings and died in 1883 in relative poverty at Watsonville. He is buried in Gilroy.

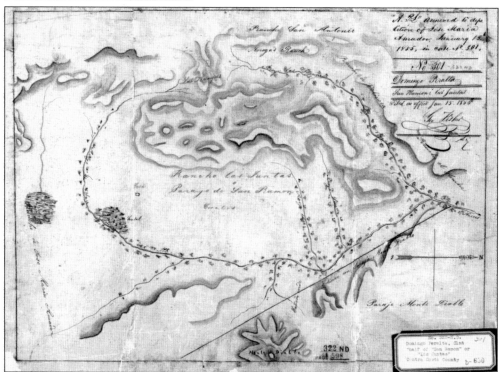

AMADOR PROPERTY MAP, 1855. This sketch of Jose Maria Amador's property in 1855 shows just how varied and diverse the land was at that time. Topographical markers, such as hills, summits, rivers, and trees, typically served as boundaries for early Spanish and Mexican land grants. With the coming of immigrants and Americans to the gold fields of the Sierra Nevada, Jose Maria Amador sold portions of his property in what is modern-day Alameda County. By 1855, as the map indicates, his property holdings had been reduced significantly, lying just north of the Contra Costa County line. (Courtesy Bancroft Library, University of California, Berkeley.)

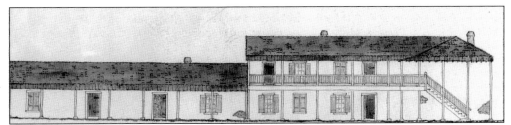

JOSE AMADOR'S RANCHO, 1850S. On a spot northwest of the present-day intersection of San Ramon Valley Boulevard and Dublin Boulevard, Amador built his home near a natural water source called Alamilla Springs. Hidden in an apartment complex, it is still flowing today. He was one of the first manufacturers and farmers in Alameda County, herding vast numbers of cattle over his broad, unfenced acres. Amador also established facilities that employed Native American laborers for tanning leather; making shoes, soap, saddles, and harnesses; weaving blankets; and even manufacturing wagons in his adobe workshops. At one time, he owned 350 horses, 14,000 head of cattle, and 4,000 head of sheep.

CALIFORNIA MAP, 1851. Driven by social, religious, and economic forces known as Manifest Destiny, the United States believed it had the inherent right to claim the western part of the continent for itself. In 1846, a war exploded between the United States and Mexico. After a year of bitter fighting, Mexico had no choice but to surrender. California became a U.S. territory on February 2, 1848. On February 11, 1848, gold was discovered at Sutter's Mill. When thousands of people flooded into the region in a mad dash to strike it rich, political leaders had the clout to ratify a constitution in November 1849. The U.S. Congress recognized the constitution in 1850. On September 9, California was admitted into the union as the 31st state. A practical man by nature, Jose Amador adapted to the changes and lived in California for the rest of his life, until his death in 1883.

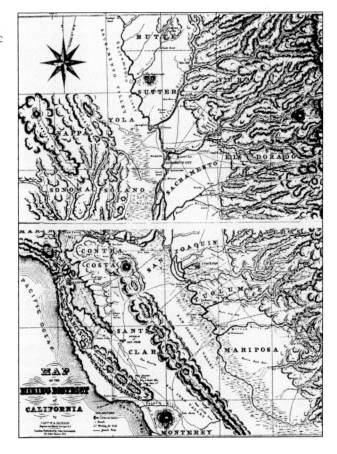

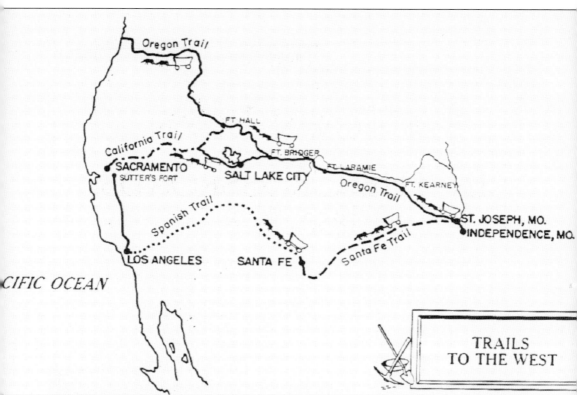

CALIFORNIA TRAIL MAP, 1850s. When James Marshall discovered gold in 1848, he unwittingly ushered in one of the greatest mass migrations of people in modern history. An event of this caliber necessitated the establishment of a transportation system to facilitate the movement of mail, supplies, and people. Led by experienced mountain men and trackers, the creation of a trail system brought hopeful pioneers to California. Crossing thousands of miles of open territory in covered wagons, they made an arduous trip at best, with hazards lying in wait behind every corner. Wild animals, rivers, mountain passes, hostile Native Americans, bandits, sickness, exhaustion, and starvation were dangers constantly nipping at the heels of every person brave enough to make the journey west.

Two

A Town Born
in the Crossroads
1850–1878

MICHAEL MURRAY, C. 1855. Murray arrived at Mission San Jose in 1846 with his sister Eleanor and brother-in-law Jeremiah Fallon. There Michael met his first wife, Amelia Nash. When gold was discovered in 1848, Murray tried his luck at mining. At this time, there were 2,000 Americans living in California. By 1849, California's population had ballooned to 53,000 people. As did happen with so many miners, Michael Murray returned to the Mission San Jose area with none of the fortune he sought for himself and his family. In 1850, he purchased 1,000 acres of land from Jose Amador and built a home for his family in what is now Dublin. He became a naturalized citizen of the United States in 1859 and, from 1860–1861, served as a county supervisor for Alameda County. It is about this time his first wife, Amelia, died. He married his second wife, Catherine, not long after. Michael died in 1881 in San Francisco at the age of 74. (Courtesy Murray family.)

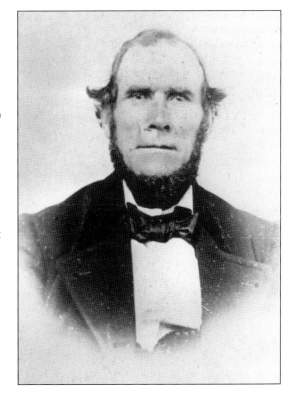

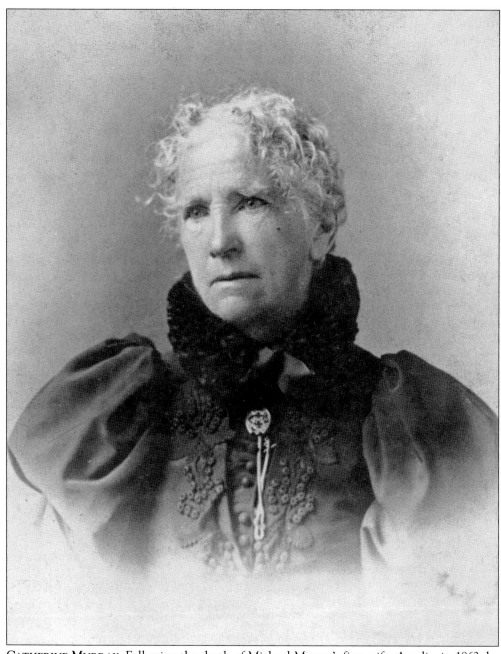

CATHERINE MURRAY. Following the death of Michael Murray's first wife, Amelia, in 1862, he married Catherine Bensen, a native of Ireland who was born in 1831. Catherine and Michael's first son, Thomas F. Murray, was born in San Francisco in 1866. They had three other children over the next five years: Isabel, Daniel, and Madeline. Catherine died in San Francisco in 1911 at the age of 80. Services were held for her at St. Raymond's Church. (Courtesy Murray family.)

MICHAEL MURRAY LAND DISPUTE, 1851. Not long after Michael Murray and Jeremiah Fallon purchased land in Dublin, a dispute arose between them and J. D. Pacheco. The new owners were under the impression Pacheco was contesting the measurement of the land. Jose Maria Amador, who wrote the letter, stipulated this was not the case. Furthermore, he indicated half the land in dispute would go to the lawyers representing Murray and Fallon if the case went their way. Amador strongly advised Michael Murray not to pursue the legal route, believing the lawyers were the ones really behind this. He signed the letter, "Your loving friend, Jose Maria Amador." Despite the difference of language and culture, these two men bridged this gap and formed a strong friendship with each other. (Courtesy Pleasanton Museum on Main Street.)

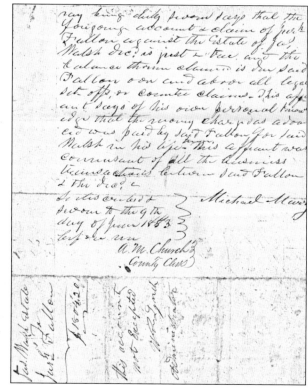

JEREMIAH FALLON AND MICHAEL MURRAY SALE OF LAND, 1853. This is the first recorded sale of land in the area from one non-native Californian to another. Finding kinship in their fellow Irish neighbor, James Walsh and Michael Murray accepted Jeremiah Fallon's offer of $1,854.20 for the 185-acre plot in 1853. When the county clerk began writing up the contract, he initially wrote down that the property resided in Contra Costa County. Remembering the state legislature formed Alameda County three months before, he made the correction. (Courtesy Pleasanton Museum on Main Street.)

COUNTY AND CITY, TOWNSHIP OR SCHOOL DISTRICT.	NAME OF SCHOOL.	Children between the ages of 4 and 18 years.	Children reported previous y'ar.	Orphans.	State Fund, apportioned Dec. Dist.	State Fund apportioned June Sch.	State and County fund. Oct. Dist.	County Fund received.	County Fund paid out.	State Fund apportionment previous	Paid for School Libraries and Apparatus	Building, rent, and purchase School Houses	Time of Services of Teach. m's. w's.	Salaries per Month	State Fund paid for Salaries	Salaries paid by Patrons of School.	Total paid Salaries
Oakland Township..	Not given	71	52			$52 65	$52 65										
Oakland City.......	District No. 1	132	153	11	$182 40					$416 65		$60 00	13	$150 00 80 00	$213 00		Not Rep'td
Clinton Township...	" "	112			134 40							{ 500 00 } { dona'd. }	5				"
Alameda Township.	Alameda	103	50		123 60			17 21		103 13		209 34	3	100 00	69 60	$88 00	$158
Eden Township.....	Eden Vale........	115	92	2	138 00			31 67	$31 67	182 319 80		606 15	9	100 00	126 82	300 00	426 8
Murray Township...	District No. 1	59			70 80									83 50			
Washington Town'p.	" No. 2	133	179		159 60		144 80	61 00	61 00	385 62		78 50	6	112 50	104 40	337 50	441 9
	7 Schools.	745	526	13	$808 80	$681 03	$197 45	$163 13	$93 73	419 55 819 50	$1,293 99		$625 83	$515 82	$726 50	$1,029 2	

Note.—Nine Boards of Trustees organized, with

Township No. 1	1st District	136	91		$163 20					433 97		$27 00	9	$120 00	$283 00	1,055 00	$1,338
" No. 2	Ione Valley........	102	194	7	195 60								10	125 00	363 00	655 75	1,018 7
"	2d District........	61			No Sch'l rep							592 90	3	100 00	300 00	561 00	1,073
" No. 3	1st District	244			292 80								3	100 00	215 00		
"	2d District........	73	457		87 60							223 40	3	100 00	63 98	232 02	300 0
" No. 4....	1st District........	81			97 20							32 12	7	60 00 80 00	37 00 112 55	149 24	299
" No. 5....	"	105	33		126 00							13 50	3	90 00	135 00	135 00	240 0
" No. 6....	"	63			75 60							53 04	8	80 00	295 75	295 75	595
" No. 10....			43														

ALAMEDA COUNTY LIST OF SCHOOLS 1854–1855. Although Dublin, at this time, was nothing more than a loose collection of family farms, the people living there, most of whom probably had little formal schooling themselves, still recognized the value of an education. Many of these pioneers came to America so they could ensure a better life for their children. They decided the best way to make this happen was the formation of a local school. In 1854, the county board of supervisors in Oakland approved their request, and Murray School came into being. Under the trusteeship of Michael Murray and John Kottinger, they hired a teacher from the nearby township of Eden, C. A. Crane. With a first-year enrollment of 59 students, ranging from 4 to 18 years old, it is safe to say the people of Murray Township fully supported their new school.

Total Expenditures for Schools within each District. 1855.	1854.	Assessed value of Property in the County.	Grade of School.	Number of Boys. 1855.	1854.	Number of Girls. 1855.	1854.	Pupils attending School. 1855.	1854.	Daily average attendance. 1855.	1854.	TEACHERS.	TRUSTEES.
				28		43		15		14		Martha Percy	F. S. Smith, J. A. Hobart, F. C. Coggeshall.
$273 30	$3,090 00		Primary.	73	95	77	58	145	103	59	45	{ F. Warner....... } { Sarah H. Walker. }	E. J. Willis, Superinted't, } Artemas Davison, Clerk, } City Board.
500 00			"	52		60		28		13		Joseph Sparrow ...	Asa Walker, Robert Parke, T. S. Smith.
384 34			"	51	23	52	27	19	20	17	14	Mrs. A. S. Page	T. J. Stratton, James Mullington, E. B. Taft.
986 14	480 00		"	63	50	52	42	44	20	16	14	{ C. A. Crane....... } { James Sullivan... }	Z. Hughes, Wm. Mattox, R. S. Farrelly.
250 00			"	34		25		17		12		C. A. Crane........	John Kottinger, Michael Murray.
693 50	75 00		"	77		56		53		31		Charles Kempeter .	Nettle Hamilton, Wm. Brier, Mr. Kelsey.
$3,086 98	$3,645 00	$3,618,360		380	168	365	127	321	143	162	73	9 Teachers.	

good prospect

$1,338 00	$242 81		Primary.	73	48	64	43	36	43	26	26	C. O. Parsons	Messrs. Hill, T. Jones, I. S. Strawbridge.
1,045 73	946 10		"	48	53	54	55	73	60	35	23	D. S. Peters........	L. Heacock, T. B. Gregory, W. Wines.
				35		26							H. A. Swan, R. Bexton, I. M. Scott.
1,665 90	400 00		"	126	86	118	71	80	43	70	28	J.Goodwin, Miss Kain } Mr. Gibson	I. M. Ballard, J. C. Williams M. Rice. W. L. Pratt, L. Post, Wm. Rickey.
523 40			"	34		39		45		30		J. O. Peters........	
358 91			"	45		36		32		18		Mrs. Wildman......	Messrs. E. McIntire Hubble, Wildman.
253 50	623 98		"	51	18	54	15	22	33	15	19	J. M. Reynolds.....	B. Burt, E. L. Davis, L. H. Hinckston.
648 44			"	32		31		30		14		D. Townsend.......	Col. Lagrave, W. A. Norman, J. Roland.
	180 00			27			16		43		28		
$5,833 88	$2,392 89	$1,433,150		441	232	422	200	318	222	208	126	9 Teachers.	

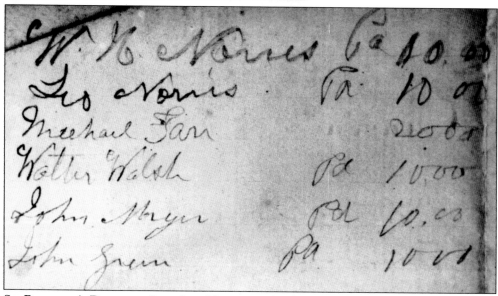

St. Raymond's Donation List, 1859. After Jose Maria Amador sold a parcel of his property to Michael Murray in 1851, Dublin continued to attract others who wished to start new lives for themselves. But as the years passed, many of the town's Catholic parishioners found it increasingly impractical to fulfill their religious duties at Mission San Jose 15 miles away. In an act of community spirit and foresight, they decided to pool their resources and build a church of their own. The inclusion of the Fallon, Devany, Murray, Nash, Donlon, Bernal, Murphy, and Tehan families shows just how many of Dublin's pioneers offered their support in this important civic and religious project.

St. Raymond's Donation List, Leo Norris, 1859. One of the men who pledged to support the building of St. Raymond's church was Leo Norris, as his $10 donation attests. He and his wife, Jane Norris, came to California in 1846. In 1850, the Norrises purchased the northwest corner of Jose Maria Amador's Rancho San Ramon property, near modern-day Bollinger and Crow Canyon Roads. Leo Norris and William Lynch (no relation to the author) built the first wood-frame house in the area.

THOMAS DONLON HEADSTONE, 1859. With his pledge of $50 to the St. Raymond's building project, the single highest amount listed, the generosity of Tom Donlon is quite apparent. Sadly, he did not live to make good on his gift, evidenced by the empty spot next to his name on the donor sheet. While helping to build the church in 1859, Tom fell off the roof and died. In an act of unanticipated irony, he was the first person buried in the adjacent cemetery.

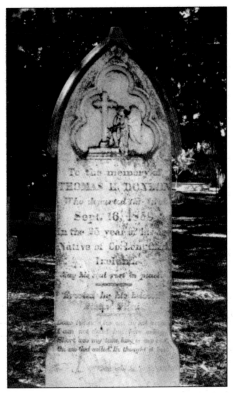

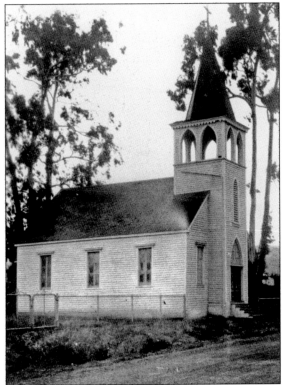

ST. RAYMOND'S CHURCH. St. Raymond's was the first Catholic church built in Alameda County, thanks in part to Michael Murray and Jeremiah Fallon, both of whom donated a four-acre plot of land to the diocese in 1858. It was consecrated in April 1860 by Archbishop Alemany of San Francisco and Father Federa of Mission San Jose. Father King of St. Mary's in Oakland rode on horse from Oakland to Dublin once a month for Mass.

21

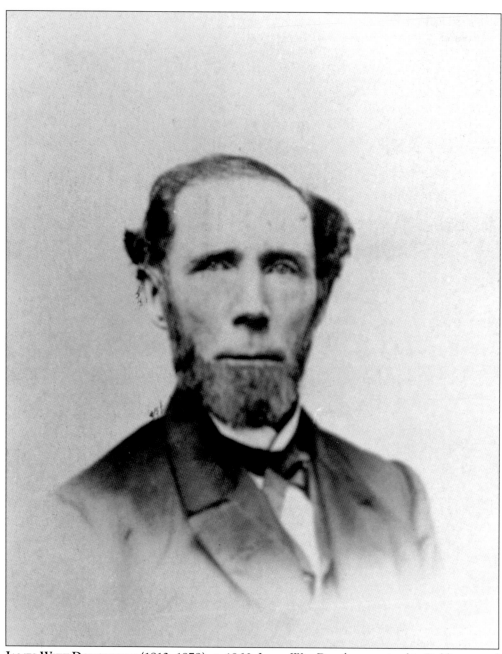

JAMES WITT DOUGHERTY (1813–1879), C. 1860. James Witt Dougherty arrived in Dublin around 1852, along with his partner William Glaskins. At the time, Jose Maria Amador held the largest parcel of land in the area. With fierce determination and unrelenting persistence, Dougherty finally convinced Amador to deed him and Glaskins 10,000 acres at a price of $2.20 per acre. Not long after, other settlers came to live on the land Dougherty claimed for himself. They set up tents and squatted on lands with cloudy titles. Protestant and American-born Dougherty's rugged individualism sharply contrasted with the attitudes of the Catholic, Irish-born settlers who believed land should be shared. In the year of his death in September 1879, Dougherty owned 17,000 acres, the second largest in the area. (Courtesy Dougherty family.)

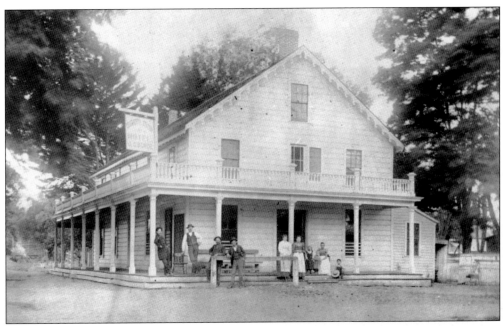

DOUGHERTY STATION HOTEL. In 1857, Congress voted to subsidize a semiweekly overland mail service. The line was to run from the Mississippi to San Francisco. James Witt Dougherty recognized the value of owning a hotel in the crossroads of stagecoach lines traveling the length and breadth of California. His instincts proved correct. Built in 1862, the success of his hotel inspired the town's name—Dougherty Station. In this photograph taken around 1900 are John C. Bonde, Mrs. Martin Hansen, Helen Bonde, Emma Bonde, Mrs. John Bonde, and Victor Bonde.

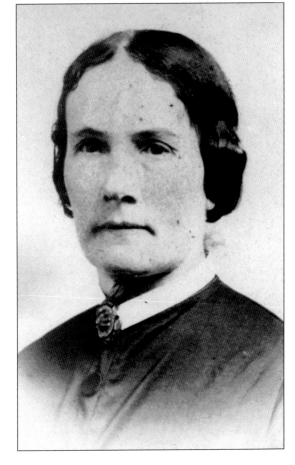

ELIZABETH DOUGHERTY. Elizabeth Dougherty, wife of James, lived in the Jose Maria Amador adobe with her family until the Hayward earthquake of 1868 severely damaged it. They tore what remained down and built a frame house on roughly the same site (near modern-day Dublin Boulevard and San Ramon Road). She lived there until her death in 1887. (Courtesy Dougherty family.)

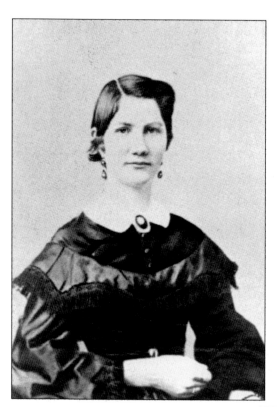

ADA DOUGHERTY, DAUGHTER OF JAMES AND ELIZABETH. Ada Dougherty was born in Mississippi in 1845. Arriving with her family in California at seven years of age, she grew up in a world of limitless possibilities. Her life was cut short, however, when she unexpectedly died in 1866 at the age of 21. As this photograph attests, Ada appeared to be a young woman who possessed a strong sense of self, mixed with a quiet dignity. (Courtesy Dougherty family.)

MURRAY AND GREEN TRANSFER OF LAND, 1862. This contract between Michael Murray, his wife Catherine, and John and Thomas Green discusses the sale of land for a price of $6,000. As the terms of the contract dictate, the property was to be deeded over to the Greens, so long as they agreed that the four-acre piece of land and adjoining cemetery belonged to St. Raymond's Church in perpetuity, as stipulated by Michael Murray and Jeremiah Fallon when they first donated the property in 1858.

Jeremiah Fallon and Eleanor Murray-Fallon. Jeremiah Fallon left Roscommon, Ireland, in 1832. While sailing across the Atlantic Ocean, he met his future wife, Eleanor Murray, and her brother Michael Murray. Jeremiah and Eleanor married in 1838. Over the next seven years, they had three children—John, Mary Ann, and Ellen. In 1846, the Fallons visited Michael Murray, who was now farming in St. Joseph, Missouri. Michael persuaded them to travel to California. After purchasing oxen and a covered wagon, they arrived at Mission San Jose six months later. In 1847, a daughter named Catherine was born to the Murrays. She was the first non-Spanish, non–Native American child born at the mission. Their joy did not last long, however. Their son John ate some unripe plums picked in the mission gardens and died. When gold was discovered at Sutter's Mill in 1848, both families tried their luck at prospecting. The Fallons and Murrays were not very successful, however. To help make ends meet, Eleanor served meals to hungry prospectors, who paid her with gold dust or nuggets. Despite Eleanor's limited success as a businesswoman, Jeremiah decided to return to the mission area, this time stopping near Dublin in 1850. He bought 246 acres of land from Jose Maria Amador for a price of $1,500. In 1864, Jeremiah Fallon died at the age of 49. Eleanor lived in Dublin until her death in 1896. Both of them are buried in St. Raymond's Cemetery.

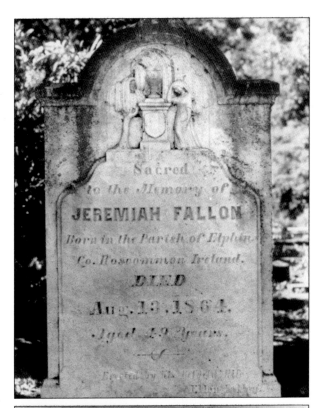

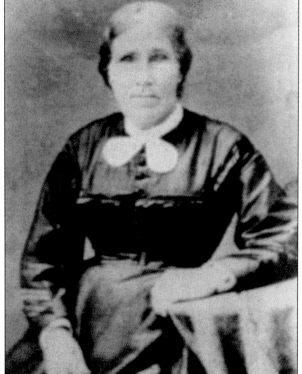

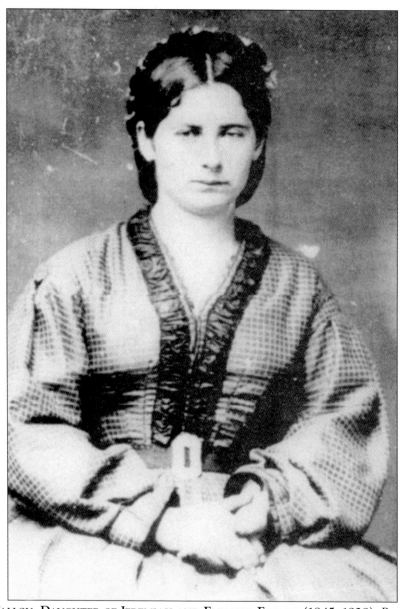

ELLEN FALLON, DAUGHTER OF JEREMIAH AND ELEANOR FALLON (1845–1928). Born in New Orleans in 1845, Ellen arrived at Mission San Jose with her parents, Jeremiah and Eleanor, in 1846. After a short stint in the Sierra Nevada, the Fallons moved to Dublin in 1850 and bought a parcel of land just south of modern-day I-580. Contracting the services of carpenter Peter Arnold, Ellen's father, Jeremiah Fallon, cut down lumber from the Moraga Valley and hauled the timbers back to Dublin by oxen. He completed the house in 1852, Ellen's first real home. Despite an increasing number of farms and ranches in the area, Dublin was still largely a wilderness area. Bears and mountain lions often came out of the hills and roamed around in the area at night. When Ellen was old enough to marry, she chose William Tehan from a number of suitors. They were the first couple married at St. Raymond's Church (1865) and went on to have 10 children of their own. Ellen quietly passed away in 1928, surrounded by all her living children. (Courtesy Fallon-Murray family.)

ISABEL MURRAY, MISS PLEASANT, AND DAUGHTER, 1865. With photographic technology being what it was in the 1860s, anyone who wanted a picture of himself had to travel to those places where a photographer had set up a studio. In the case of Dougherty's Station, this meant San Francisco. Pictured here from left to right are Isabel Murray, Miss Pleasant "Madam" from New Orleans, and Isabel's daughter. (Courtesy Leland Sobrero.)

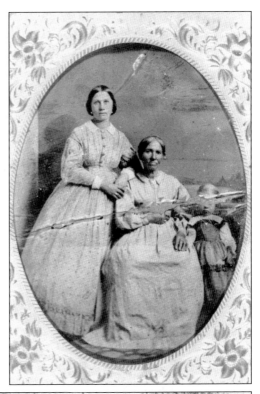

ELEANOR FALLON STATE AND COUNTY TAXES, 1867–1868. After the death of Jeremiah Fallon in 1864, Eleanor not only had the responsibility of raising her family, but she also had to learn how to manage the business affairs of her late husband's estate. A. Huff, the county tax collector, assessed the value of her 20 acres of land at $1,920, and her personal property worth an additional $443—with the tax bill coming to a total of $51.98. The amount of tax people pay for their property in Dublin has gone up somewhat since then.

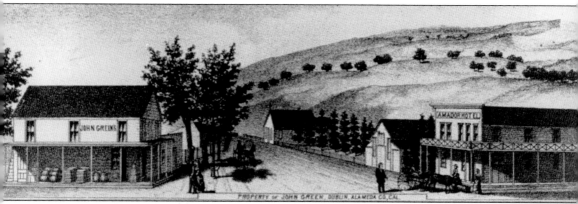

A TOWN IS BORN, C. 1867. Many local historians regard the building of Green's store as the beginning of Dublin. Born in Elfeet, Ireland, in 1823, John Green arrived in New York City at the age of 13. At the urging of his brother, he moved to San Francisco the next year. There John opened a drugstore, but he soon wearied of this business, loaded all of his possessions into an oxcart, and moved to Dublin around 1857. There he met and befriended Michael Murray. When the latter decided to move to San Francisco, John Green purchased his property for $6,000. He built a general merchandise store in 1860 (at modern-day Dublin Boulevard and Donlon Way). This drawing made in the early 1860s is the earliest known depiction of Dublin, situated along the Butterfield Overland Stage route. John Green recognized the financial opportunities that existed in a town literally situated in the crossroads and built the Amador Valley Hotel two years later. In his spare time, John Green served as an Alameda County supervisor for Murray Township from 1863 to 1866 and from 1877 to 1882. He died in Dublin in 1895. (Courtesy Green family.)

JOHN GREEN LEDGER, 1867–1868. This ledger, used by John Green for a period of 30 years, shows the daily business of the people of Dougherty Station, soon to be named Dublin. He chronicled the needs of farmers and family members alike as they went about their daily business. With great efficiency and eye for detail, he would write down the date of a particular purchase, who purchased it, what items were sold, how much each item was, and if the price had been paid. (Courtesy Green family.)

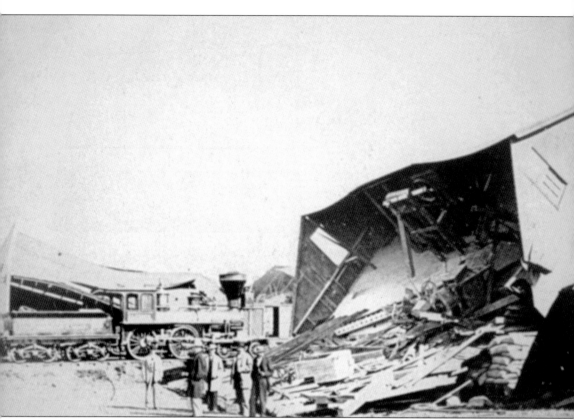

HAYWARD EARTHQUAKE, FLOUR MILL, 1868. On October 21, 1868, a 7.0-magnitude earthquake ruptured along the Hayward Fault. The quake caused 30 deaths and $3 million in property loss. At the time, this was known as "The Great San Francisco Earthquake" because the city suffered so much damage. Most of Mission San Jose was likewise destroyed in the great trembler. Buildings and property also suffered damage in cities like San Leandro, San Jose, Santa Cruz, Gilroy, and Santa Rosa. Though there are no known photographs of Dublin after the quake struck, this photograph of the flour mill in Hayward gives a hint as to what the people of the area went through, especially when contemporary accounts describe a two-foot-wide fissure passing just west of the old Murray house, drying up the local well. (Courtesy Bancroft Library, University of California, Berkeley.)

CHARLES AND IDA DOUGHERTY. The only son of James and Elizabeth Dougherty, Charles tried unsuccessfully for years to incorporate a plot of land he had inherited from his father as the "City of Dougherty" from the then-unincorporated town of Dublin. In 1907, he registered a map with the board of supervisors showing a 10-acre town to be called "Dougherty." The town never developed since the Irish-dominated board members consistently rebuffed him. Charles and his wife, Ida, enjoyed the better things of this world, including expensive cars and European and Asian junkets in many circles of the rich. Their house, Ogeedankee, was one of the finest in the area for many years. (Courtesy Dougherty family.)

31

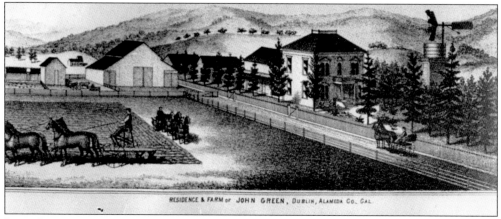

RESIDENCE & FARM of JOHN GREEN, DUBLIN, ALAMEDA CO. CAL.

JOHN GREEN'S FARM AND HOUSE. Known for his astute business practices, John Green's successes also flowed into his personal life. As seen in this image from the late 1860s, he was obviously a man of tremendous means. Taking advantage of the seasonal rains and fertile soil, John Green likewise prospered as a farmer. (Courtesy Green family.)

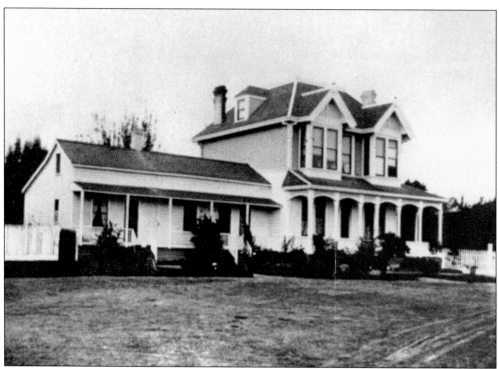

JOHN GREEN HOME. In 1889, John Green purchased and built an addition to the old homestead originally erected by Michael Murray. The house boasted a parlor, dining rooms, kitchen, pantry, library, and several bedrooms. The world-famous trotting horse Directum was bred on this farm and trained on a half-mile racetrack located elsewhere on the property. In the mid-1920s, the Murray portion of the house was separated and moved about 100 feet south.

Know all Men by these Presents, That the
Central Pacific Railroad Company, (successor to "The Western
Pacific Railroad Company" and "The Central Pacific Railroad Company of
California," Consolidated,) in consideration of the sum of ———
Two hundred ——— *($200)* ——————————— dollars,
to it paid by *John E. Martin and Dennis Martin*———
of *Alameda* ——— County, California, the receipt whereof is here-
by acknowledged, hereby gives, grants, bargains, sells and conveys to the said ———
——— *John E. Martin and Dennis Martin* ———
their — heirs and assigns, the following described tract — of land, situate
in *Alameda* ——— County, California, to wit: *the North*
East quarter (N.E.¼) ———

of Section No. *Thirty three (33)*—, in Township *Two (2) South*—
of Range *One (1) West* Mount Diablo base and meridian, containing
One hundred and Sixty ——— *(160)* ———
——————————— acres, according to the United States surveys, together
with all the privileges and appurtenances thereunto appertaining and belong-
ing. ~~Excepting and reserving, however, for railroad purposes, a strip of~~
~~land four hundred feet wide, lying equally on each side of the track of the~~
~~railroad of said Company, or any branch railroad now or hereafter con-~~
~~structed on said lands, and the right to use all water needed for the operating~~
~~and repairing of said railroads; and subject also to the reservation and~~
~~condition that the said purchaser *his* heirs and assigns, shall erect and~~
~~maintain good and sufficient fences on both sides of said strip or strips of~~
~~land; and also reserving all claim of the United States to the same as min-~~
~~eral land.~~

 To Have and to Hold the aforesaid premises to the said ———
——— *John E. Martin and Dennis Martin* ———
their — heirs and assigns, to *them* — and their use and behoof forever.

 In Testimony Whereof, the said Central Pacific Railroad Company,
has caused these presents to be signed by its President
and Secretary, and sealed with its corporate seal,
this *Fifth (5ᵗʰ)* day of *April*
A. D. 187*1*.

Leland Stanford
Pres't C. P. R. R. Co.

E. H. Miller Jr.

JOHN AND DENNIS MARTIN DEED, 1871. John and Dennis Martin paid $200 to the Central Pacific Railroad Company (CPRR) for a piece of land known as the Fourth East Quarter in the Mount Diablo Basin. The Martins settled in the valley in 1850 and contributed money and labor to the construction of the first Murray School in 1856 and St. Raymond's Church in 1859. It is interesting to note that Leland Stanford, the president of the company, signed this agreement. An influential man of his day, Stanford became governor of California in 1861 and, in the same year, bought stock in CPRR. In 1869, he drove in the golden spike that joined the transcontinental railroad. In 1885, he founded the university that bears his name. (Courtesy Martin family.)

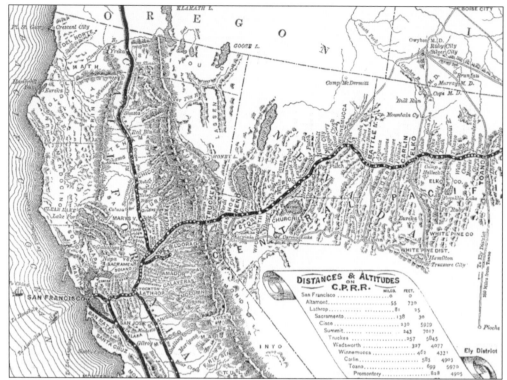

CPRR MAP, 1871. In the years following the gold rush stampede, stagecoach routes made Dublin a desirable location for settlers eager to establish themselves in a relatively prosperous area. Restaurants, hotels, and a general store were busy locales. But the bustling community was short-lived. When the transcontinental railroad was completed in 1869, smaller rail lines popped up between major towns and cities throughout the Bay Area. As this 1871 map indicates, business shifted from the stagecoach routes passing through Dublin to the locomotive stops in Pleasanton and Livermore. As a result, the townspeople suffered through an economic collapse for many years. (Courtesy Central Pacific Railroad Photographic History Museum.)

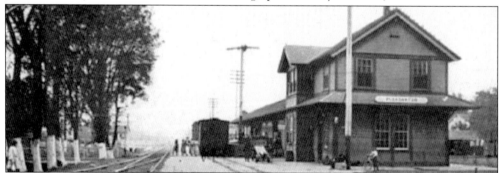

PLEASANTON CPRR STATION. The arrival of the first train in Pleasanton in 1869 guaranteed that this tiny village would soon become the principal center of commerce and culture for the entire region. Soon most of the commerce coming in and going out found itself in the boxcars of the CPRR. Ironically, this dynamic, which had brought economic hardship to Dublin, became the means of revitalizing it. Agricultural enterprises could now ship their products by rail to markets never thought possible, resulting in renewed growth in the community. (Courtesy Bill Hankins.)

Three

A SEARCH FOR IDENTITY
1878–1908

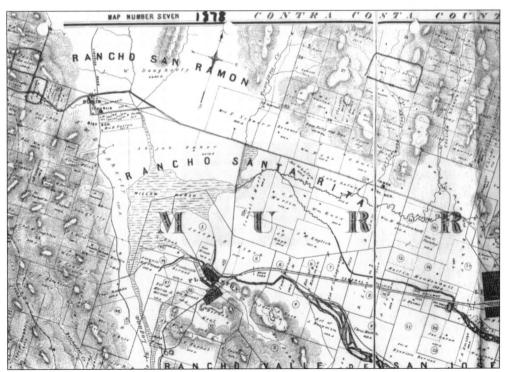

ALAMEDA COUNTY MAP, 1878. This map drawn in 1878 shows the locations and sizes of many of the family farms located around Murray Township—pioneer families like the Fallons, Greens, Murrays, Doughertys, Devanys, Donlons, Martins, and Hughes. This map is also noteworthy since it is the first official record that refers to Dougherty's Station as Dublin. The tide had begun to swing in favor of the Catholic Irish living in the area, standing opposite Protestant Dougherty.

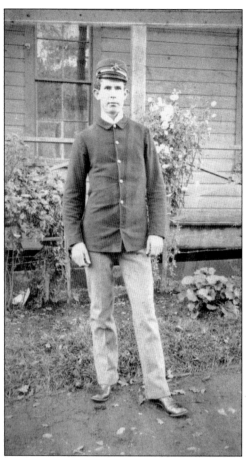

ROGER FALLON. Fallon was born in Dublin in 1853 after his parents, Jeremiah and Eleanor Fallon, moved into the area from Missouri. Before he grew his distinctive moustache, he had enlisted in the military in his early 20s. After returning to Dublin, he too made his living as a farmer. Known as a great shot, horseman, and roper, he died in 1932, having never gotten married. Roger Fallon clearly considered the name of his home to be Dublin when he signed Elizabeth (Eliza) Devany's autograph book in 1886. (Courtesy Virginia Dold.)

Subscribed and Sworn to, *before me, this* _16 th_ day

of _June_ *A. D.* 188 2

Maro. P Kay , Deputy Clerk.

———————— ✦ ————————

I, _Andrew Ryder_ , Clerk of the Superior Court, in

and for the County of Alameda, the same being a Court of Record,

having Common-Law jurisdiction, a Clerk and Seal, do hereby certify

that the foregoing is a true copy of the original Declaration of Intention

of _Jacob Ever Hansen_ to become

a Citizen of the United States of America, now of Record in my office.

To Attest and Certify which, I have hereunto set my

hand and affixed the Seal of said Court, this

16 th day of _June_ A. D. 188 2

Andrew Ryder , Clerk,

By _Maro. P Kay_ , Deputy.

JACOB HANSEN CITIZENSHIP PAPERS, 1882. For many immigrants, becoming a naturalized citizen of the United States was a prize far more valuable than almost anything else a person could ever attain. Pursuing a dream of freedom and prosperity, people like Jacob Hansen braved countless hardships just for the chance of making a better life for himself in America. On June 16, 1882, part of that dream came true. (Courtesy Hansen family.)

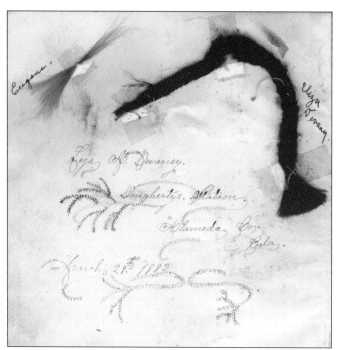

Eliza M. Devany.

Dougherty's Station

Alameda Co;
Cal.

March 28th 1882

ELIZABETH DEVANY AND M. F. MURRAY. The issue of what name the town should give itself arises in interesting places. Sometime around 1881, Elizabeth Devany, daughter of Michael Devany obtained an autograph book. Over the next five years, she took it to her friends living in and around the surrounding area, asking them to sign their name. Many of the people also wrote a poem, the date, and most importantly, indicated where they lived. Based on her own entry, she considered the name of her town as being Dougherty's Station. Three months later, M. F. Murray referred to the town as Dublin. (Courtesy Virginia Dold.)

To Eliza.

Life is a volumne,
From youth to old age;
Each year is a chapter,
Each day is a page.
May none be more charming,
More womanly true;
Than that pure, and noble.
Sketched yearly by you.

Your Sincere Friend

Dublin June 7th 82 M. F. Murray

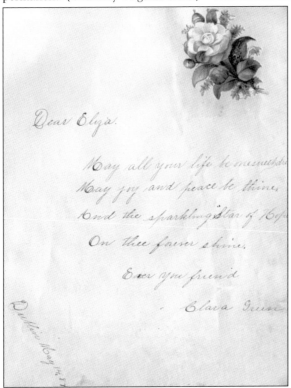

MARY AND CLARA GREEN. Two years later, uncertainty regarding the town's name seems to be as strong as ever, even between family members. Mary Green (17), daughter of John Green, calls the town Dougherty's Station in Eliza's autograph book. Her sister Clara (16) refers to it as Dublin just six days later. The issue went on for another 20 years when, in 1908, the name Dublin was made permanent. (Courtesy Virginia Dold.)

JOHANNA AND PETER NIELSEN, C. 1889. Originally from Denmark, Peter Nielsen immigrated to California in the 1880s, settling in Dublin. He became a naturalized United States citizen in 1890. The 1910 U.S. Census states he was a farmer, spoke Danish, and could read and write. He leased large tracts of land from Charles Dougherty on what is now Camp Parks. He married Johanna Nielsen and raised four sons—Alfred, Rudolph, Thomas, and Erhart. (Courtesy Roxanne Nielsen.)

MICHAEL DEVANY OBITUARY AND HEADSTONE, 1890. Having left Roscommon, Ireland, in the late 1840s, Michael Devany and his wife, Mary, arrived in New York City. They later traveled to Missouri and had two children. The Devanys arrived in San Francisco in 1852. In 1858, Michael moved his family to Dougherty's Station and made a new home for them. There Mary had four more children, including her youngest daughter, Eliza. Michael purchased two plots of land and became a farmer. After the death of his wife, Mary, in 1881, he lived alone until his own death in 1890. It is noted in his obituary that St. Raymond's Church was filled to overflowing and his funeral was the largest ever witnessed in the valley. His pallbearers were Michael Coyler, Rod Fallon, William Fallon, James Welch, Thomas Wells, and Michael Murray. (Courtesy Virginia Dold.)

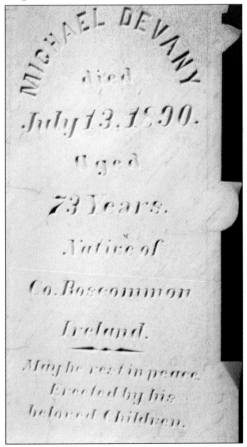

Death of a Pioneer.

Last Sunday afternoon at about two o'clock death closed the eyes of Michel Devany of Dublin an old and highly esteemed citizen of that town, a pioneer of sterling worth and one who has battled through the vicissitudes accompanying ranch life in Amador valley in what may be termed early days. Mrs. Mary Devany his beloved wife passed from this mundane sphere in 1881 at the age of 45 years. Since the death of his helpmate Mr. Devany has been living very quietly upon his ranch at Dublin surrounded by his loving children of whom there are six. Mr. Devany was born in Ireland but came to America at an early age. In 1853 he came to the Pacific Coast and located at San Francisco where he resided until 1858 when he removed to Dublin with his family and lived there up to the time of his death at the ripe old age of 73 years. Six children, two sons and four daughters survive him, all married and comfortably situated but one daughter who still remains single. The funeral services took place last Tuesday at 10 a. m. at the Dublin Catholic Church. Fathers Coyle and Powers officiating. After mass the remains were interred in the Catholic cemetery just off from the church. As Mr. Devany's friends during life were legion the church was filled to overflowing and the funeral cortege the largest ever witnessed in this valley. The following gentlemen acted as pall bearers: Michel Coyler. Rod Fallon, Wm. Fallon, James Welch, Thos. D. Wells and Mike Murray.

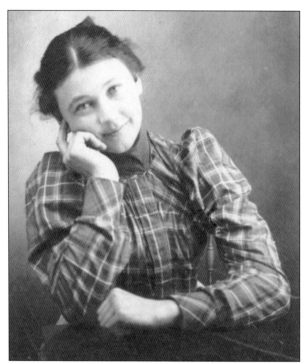

MINNIE MARTIN, C. 1891. Born in 1879, Minnie Martin poses for this picture as a young, idealistic girl of 12 or 13. With her older brother, Edward, and parents, John and Mary Martin, she grew up in the farming community in and around Dougherty Station in the 1890s. In 1903, she married a local farmer named Jacob Hansen. Together they had six children; two died at an early age. (Courtesy Pamela J. Reilly Harvey.)

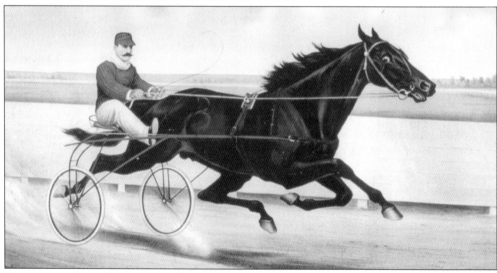

DIRECTUM, 1893. In the mid-1870s, John Green decided to try his luck at horse racing. After 20 years of raising and training trotting horses, he produced his most successful foal—Directum. His horse eventually set a world record in 1893 for a 1-mile race. When John Green's train pulled up to the station in Pleasanton after his record-setting race, over 1,000 people were on hand to greet them as conquering heroes. Directum was led to a platform where a magnificent floral collar with the inscription "Directum King, 2:05.25" was placed around his neck. The Pleasanton Band appropriately played "Hail to the Chief" amid the wild cheers of the people. An agent purported to have offered John Green the staggering sum of $35,000 for the colt. He bluntly refused, saying, "I do not need the money and it does not cost me any more to keep him than it would anyone else, therefore he is not for sale." (Courtesy Green family.)

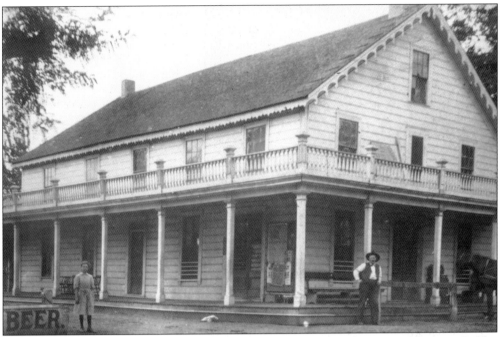

DOUGHERTY STATION HOTEL, C. 1895. Born in Denmark in 1855, John C. Bonde came to Dublin via Mount Eden in 1895. He operated the Dougherty Station Hotel for 25 years with his brother Art. The two of them were known to watch Dublin natives gather at the general store and then try to lure them back to their bar with the promise of free drinks. Henry Bevilaqua came to the town around 1920 and succeeded John Bonde as proprietor of the hotel.

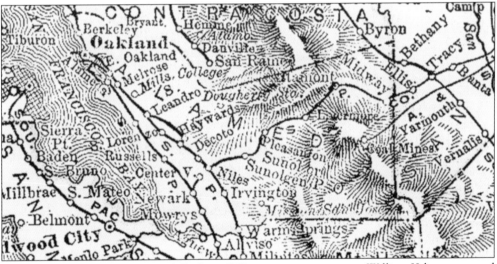

ALAMEDA COUNTY ATLAS, 1895. Early in 1890, a young entrepreneur, William Kyle, announced plans for a new transcontinental railroad that would go through Alamo, Danville, and San Ramon. By 1891, local businessmen helped complete the work. The development of the railroad helped create a broader and more successful farming industry. Throughout the valley floor, walnuts and fruits of all kinds could be moved to the markets with ease, gradually shifting agriculture away from grain crops. In an unforeseen twist of fate, the very entity that almost ruined Dublin became the means that helped to resurrect it. (Courtesy www.MemorialLibrary.com, hosted by www.USGenNet.org.)

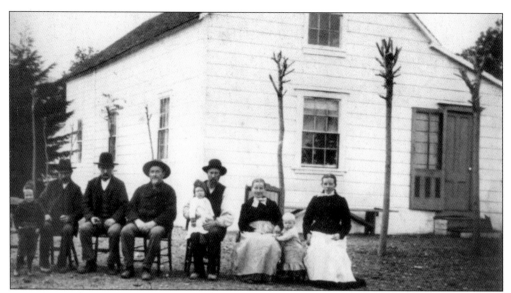

KOOPMANN FAMILY, 1890S. Born in Germany, John Koopmann arrived in California in 1852. After failing as a gold miner, he went to San Francisco and bought an interest in a schooner that sailed back and forth to Sacramento. Looking for a way to invest some of his earnings, he purchased 200 acres of land for $3,000 in Alameda County in 1864. He decided to move to this property permanently around 1870. John Koopmann lived on his farm until his death in 1873. Pictured here from left to right are Herman Koopmann, Johannes Kroeger (probably), Peter Kroeger, Johann Kroeger Sr., Mathias Koopmann holding Bertha, Margretha, John Koopmann, and Geeche Koopmann. (Courtesy Koopmann family.)

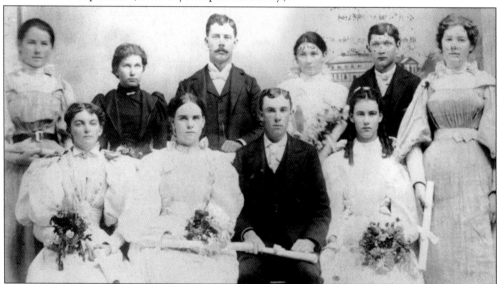

EIGHTH-GRADE GRADUATION, MURRAY SCHOOL, 1896. In an era when many children never went to school past the fourth grade, this photograph of the Murray School class of 1896 graduation is a testament to the people of Dublin who recognized the future of their children lay in an education. Pictured here are, from left to right, (first row) Bertha Hanna, Grace Wells, Thomas Wells, and Margaret Murray; (second row) Annie Tehan, Lillian Mast, Judge William Donohue (teacher), Minnie Martin, William Boyd, and Catherine Tehan.

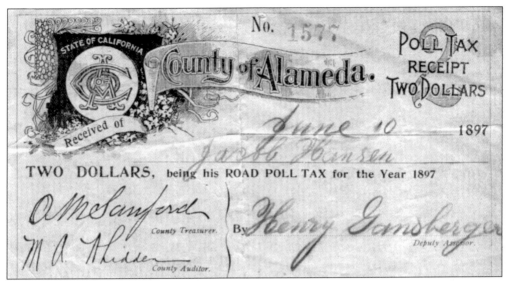

No. 1577

STATE OF CALIFORNIA
County of Alameda.

POLL TAX
RECEIPT
TWO DOLLARS

Received of

June 10 ———— 1897

Jacob Hansen

TWO DOLLARS, being his ROAD POLL TAX for the Year 1897

A M Sanford
County Treasurer.

M A Whidden
County Auditor.

By Henry Gansberger
Deputy Auditor.

JACOB HANSEN 1897 POLL TAX RECEIPT. Beginning about 1870, Danes—such as the Hansens—Germans, Portuguese, and Chinese arrived in Murray Township. Many of these immigrants pursued the dream of becoming a citizen of the United States, as Jacob Hansen did in 1882. So proud was he to be called American that after paying his $2 poll tax for the privilege of voting, he kept his receipt as a reminder of the right of citizenship offered by so few countries at that time. (Courtesy of Hansen family.)

LATE 1890S, JAMES MULVEY AND ED WELLS, BICYCLE RACERS. Born in the Dublin area in 1865 and 1869 respectively, James Mulvey and Ed Wells found themselves caught up in a new national craze sweeping America—bicycle riding. Prior to 1890, bicycling was primarily seen as a hobby for the wealthy, the only people crazy enough to ride the "high-wheelers" and "bone shakers" of the day. The introduction of inflatable tubes, sprockets, and chain mechanisms helped revolutionized bicycling, and its popularity soared throughout the United States. In short order, cyclists started to organize clubs. In 1884, the Bay City Wheelmen formed in San Francisco. The San Jose Road Club and Garden City Wheelman Club followed in San Jose, no doubt created after the construction of a velodrome in 1892. Friendly rivalries evolved between these clubs, leading to the formation of races. James Mulvey and Ed Wells went to San Jose to train and participate in those races. Finding success in their efforts, both men eventually became Pacific Coast riding champions.

Cor. LOCUST and SANTA CLARA STS.
SAN JOSE, CAL.

Thats ten cent in our money, they are just like slaves Charley. When you order a suit of clothes to day, to morow you got it same with the wash men. They charge you one cent and half for every piece you wash. Thats three yen in their money. Things are very cheap out here, thats one good thing. They wont let us go ashore on account of Boston comming from Hong Kong China, to Yokohama then some of us will be transfered to her. The Yorktown will also be here. The Russian man-a-war, the Japanese, and the American man-a-war, non of them can compard with the American. The largest american wooden ship in the world is all so laying here. Yokohama is just a sea port. Well Charley i will now close my letter for this time I will let you know some more news when I get a shore. I will now close, hoping I will here from you soon. ///

I remain
Your True Bro.
Alexander Hansen.
Yokohama.
U.S.S. Olympia
Japan

Alex Hansen
Yokohama.
U.S.S. Olympia
Japan

Address

And my regards to every body
And tell them we are getting along finely, every thing
is strange here to us.
I will never forget the Penn trip

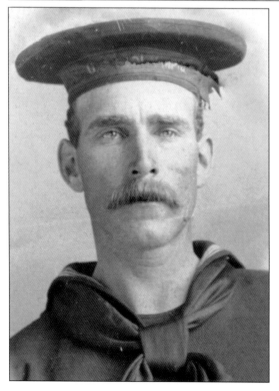

ALEXANDER HANSEN LETTER AND PHOTOGRAPH, 1898. Alexander Hansen joined the navy some time around 1897 and served aboard Admiral Dewey's flagship, the USS *Olympia*. He had no way of knowing that this decision would put him on a collision course towards one of the most important events of the late 19th century. When the United States declared war against Spain on April 25, 1898, the *Olympia*, and the rest of the Asiatic Squadron, sailed for the Philippines in search of the Spanish fleet. On May 1, both sides sighted each other in Manila Bay. When the smoke cleared, the Spanish fleet had suffered a terrible loss in ships and men, whereas Admiral Dewey's squadron suffered only a few wounded men. The *Olympia* returned to New York in September 1899. The result of the war quelled the dying embers of a Spanish superpower while at the same time laid the foundation for the United States to become one itself. (Courtesy Hansen family.)

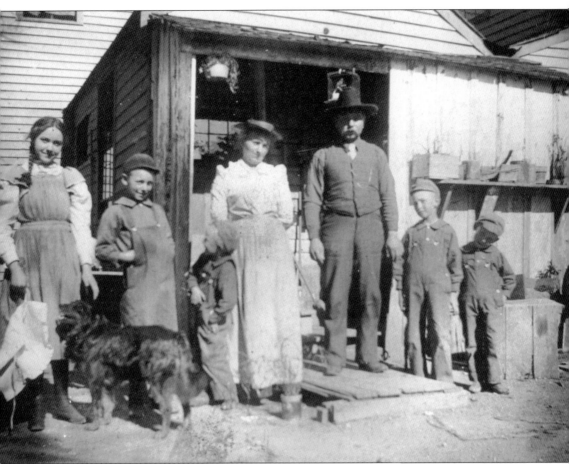

REIMERS FAMILY, 1900s. Claus Reimers was born in Germany in 1864. After arriving in Dublin, he became the proprietor of the Amador Valley Hotel. In 1892, he became a naturalized citizen of the United States. Pictured from left to right are Ellen (1887–1958) (probably), Rudolph (1888–1947), Ernest (1894–1965), Augusta (mother), Claus (father), Arthur (1891–1943), and Walter. In a common practice of the day, photographers would travel from town to town, asking people if they wanted their picture taken. (Courtesy Leo Reimers.)

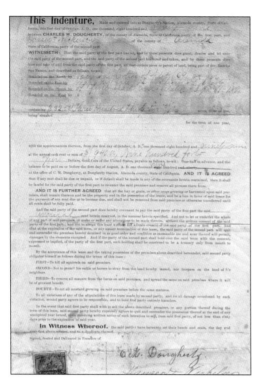

CHARLES DOUGHERTY LEASE, 1899.
According to the terms of the agreement,
Hansen and Nickersen paid Charles
Dougherty the sum of $940 for the lease
of 332 acres. By accepting the terms of the
lease, they obligated themselves to the
following conditions: 1) kill all squirrels
on said premises, 2) not to permit cattle or
horses to stray from the land, 3) remove all
manure from the barns and spread the same
on said premises where it will be of greatest
benefit, and 4) cut all mustard growing
on said premises before the same matures.
(Courtesy Dougherty family.)

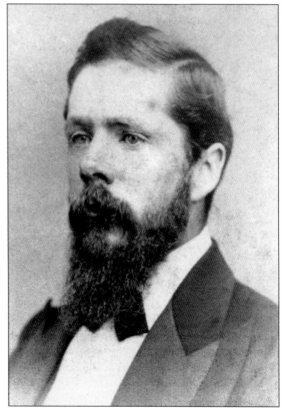

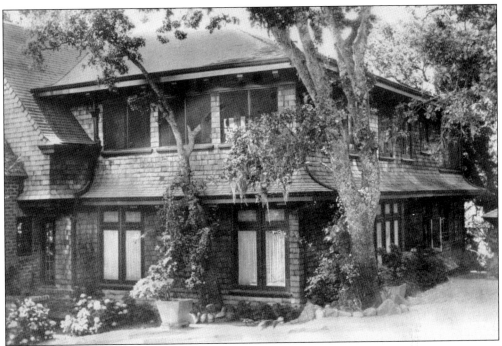

OGEEDANKEE HOME OF CHARLES AND IDA DOUGHERTY, C. 1899. A fine house for its day, Ogeedankee, which is Native American for "up the hill," included an outdoor skating rink, aviary, animal zoo, Chinese tea garden, and Japanese tea garden. Despite their wealth and status in the community, the Doughertys could not prevent their home from burning to the ground in 1918. (Courtesy Dougherty family.)

ELIZABETH ("BESSIE") DOUGHERTY. Symptomatic of the ills that plagued families living at that time, even ones as wealthy as Charles and Ida Dougherty, Bessie is another tragic example of one of Dublin's own cut down in the prime of life. Much beloved for her kind and giving heart, she also taught Sunday school to the children of St. Raymond's Church. A young woman of great beauty and faith, her death was a loss to the entire community. In honor of her memory, the Cronins, Nielsens, and Koopmanns named their hunting camp up in the Livermore hills "Camp Bessie" after her. (Courtesy Dougherty family.)

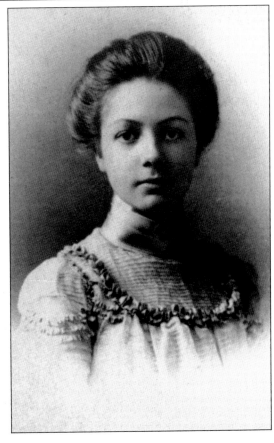

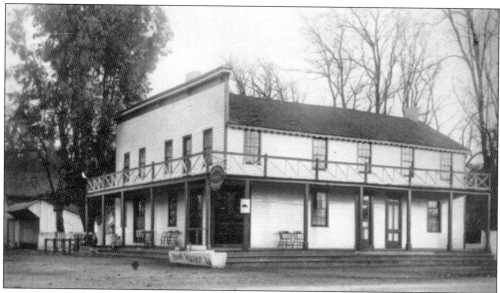

EARLY-1900s AMADOR VALLEY HOTEL. This is the Amador Valley Hotel as it looked before burning down in a fire in 1912. Built by John Green in 1862, it served the needs of travelers when stagecoach drivers stopped to water their horses. In 1873, the hotel fell under the proprietorship of William and Ellen Tehan. After the hotel was rebuilt in 1913, it became known as the Reimers Hotel, under the proprietorship of Claus Reimers.

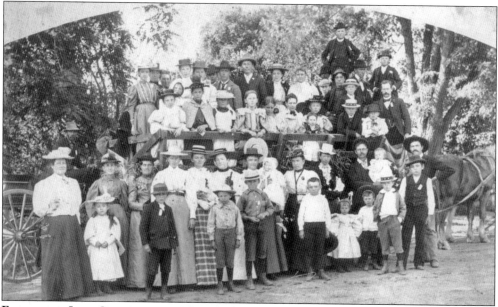

FOURTH OF JULY CELEBRATION. This photograph taken on the Fourth of July around 1900 could not express more about what Dublin represented to so many people and families. From the town's beginning, people literally came from all walks of life and many places in the world. While most immigrants maintained a number of ties to their heritage, they also had a new name to call themselves—that of American. With the Stars and Stripes draped on the front of the wagon, every person here openly embraced the chance to celebrate the freedoms offered to those who made this land their home.

EARLY-1900s HORSE-AND-BUGGY RIDE. With many of the farms miles away from each other, the most reliable mode of transportation at that time was the horse-drawn buggy. But times were changing. Straddling the length of the road, telephone poles and wires brought electricity to the sleepy hamlet and introduced Dublin to the 20th century. The Merman Leach home sits on a hill in the background.

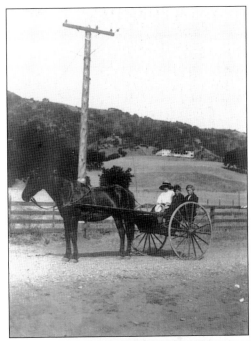

MAN AND BICYCLE, C. 1901. In the 1890s, the latest national craze, bicycle riding, was in full swing. By 1899, there were 312 bicycle factories in the United States selling one million bicycles yearly. Daring young men and women, some of whom wore scandalous "bloomers," wanted a bicycle, or a velocipede, as they were sometimes known. Enthusiasts rode city streets or, as it was for this young man, the unpaved country roads in and around Dublin.

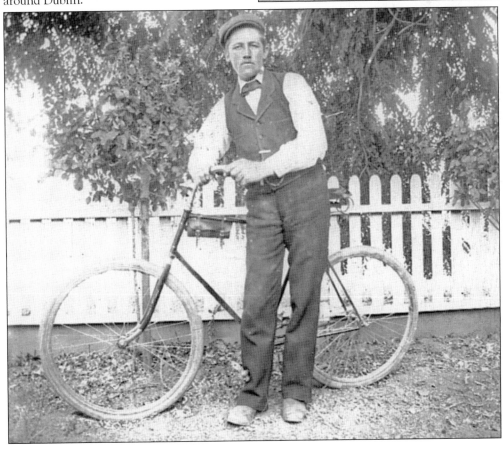

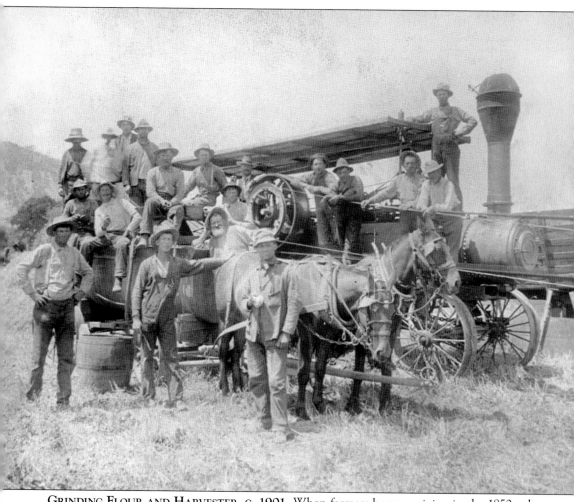

GRINDING FLOUR AND HARVESTER, C. 1901. When farmers began arriving in the 1850s, the economy of the Dublin area began to shift away from ranching. They discovered the fertile soil allowed crops to grow in relative ease, including hops, barley, hay, and fruit trees. But the work was still difficult. Farmers typically harvested their crops with a sickle. After the wheat was cut, for example, the stalks were laid down and beaten with a short broad stick to separate the grain from the chaff. They were then tossed into the air together, where the wind blew the chaff away, leaving the grain behind to be put into sacks for use as food or planting additional crops. With the introduction of the gas-powered engine, all this changed. No longer were farmers required to either use brute force or animals to harvest their valuable crops. Stationary engines, such as the one used by these Dublin farmers, began to mechanize the farmer's work, giving him the ability to harvest his crops more quickly and at a fraction of the labor needed.

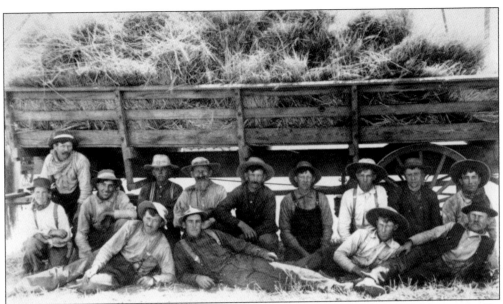

BUNDLE WAGON THRESHER CREW. Agriculture framed a family's life socially, recreationally, and fiscally. Farming families bonded with other farming families. In the spring, neighbors would come to help with the work, and then they would have a big feast and play cards and games. The next weekend, that same family would go to someone else's farm and return the favor. Taking a break from the hot afternoon sun in the shade offered by a hay wagon, a thresher crews poses for a photograph. Pictured here are Martin Stajohann, center with moustache, and Herman Koopmann, to the right of Stajohann in dark overalls.

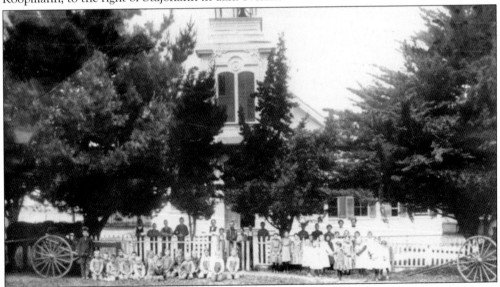

MURRAY SCHOOL, 1901. Erected in 1856, James Witt Dougherty donated the land so Murray School could be built. He named the schoolhouse after his friend Michael Murray, who was a supervisor in the township. Housing an average of 40 to 50 pupils from grades one to eight, the structure had to be moved in 1860 because of frequent flooding. Jeremiah Fallon used oxen to drag the schoolhouse to higher ground. Here the students pose for a picture, with a hint regarding their means of transportation on either side. (Courtesy County Centennial.)

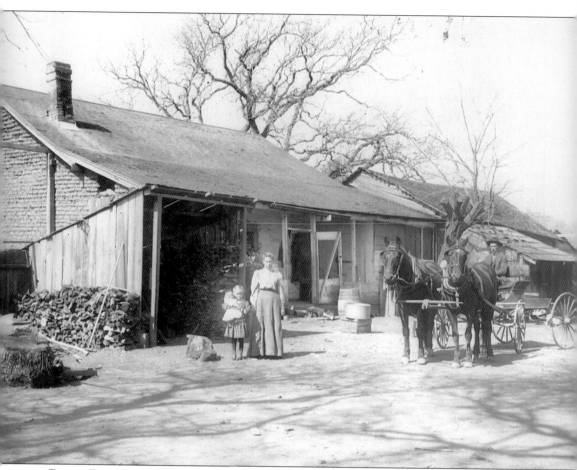

FAMILY FARM, C. 1903. Epitomizing the pioneer spirit that established Dublin decades earlier, this family shows just how hard life on a farm can be. Since wood was their primary source for heat and cooking, it was collected for use on a regular basis. Water usually had to be carried into the house from the well, heated, and then used wherever it was needed. Women typically washed the clothes by hand and then hung them on lines to dry. Animals supplied the labor necessary to plow the fields, while younger family members tended the chickens and other domesticated animals.

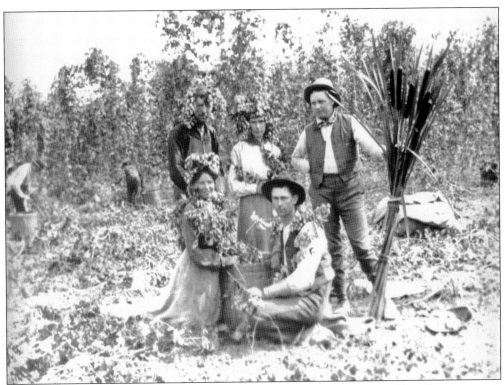

HARVESTING HOPS, EARLY 1900s. An industry that helped make the Dublin-Pleasanton area famous was the cultivation of hops. In 1893, E. R. Lilienthal purchased 300 acres of land situated between the two towns. The hop yard is set out with 6-by-6-foot poles, 16 feet high, and 42 feet apart. In each row between the poles are six rows of vines. Men, women, and children worked as laborers as they went from farm to farm to help pick the clusters of hops. The bales of hops were then wrapped in burlap sacks before being shipped to London for use in brewing beer.

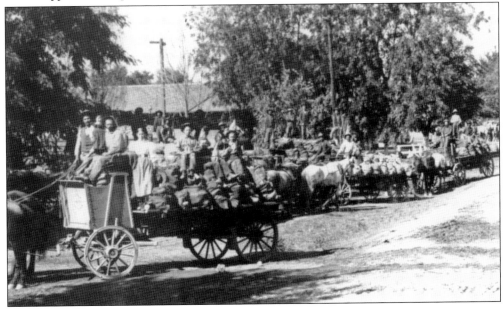

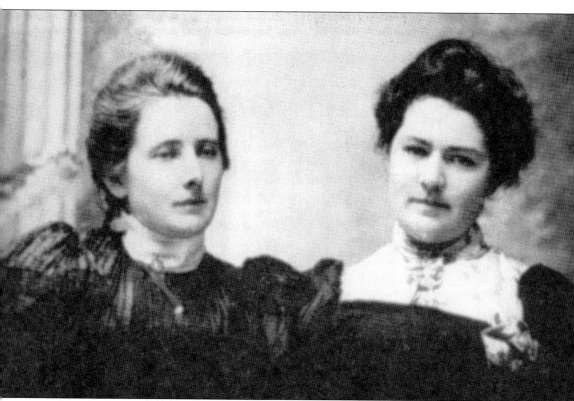

MARGARET (1874–1933) AND CATHERINE TEHAN (1880–1968), C. 1902. Daughter of William and Ellen Fallon Tehan, Margaret (left) was the second wife of Julius Dobbel, the widower of her sister Annie, who died at the age of 21 while giving birth to her first child. Julius and Margaret had five children of their own. Catherine never married. (Courtesy Tehan family.)

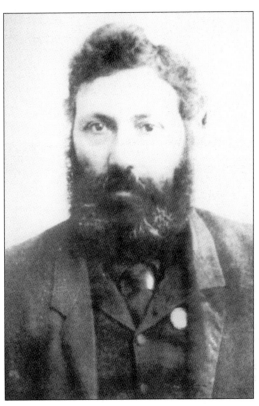

MANUEL FRANCISCO TERRA SR. AND FAMILY, C. 1904. Born in 1864, Manuel Terra came to America from Pico, Portugal, in the early 1880s. To help pay for his passage, he worked as a whaler on various ships until arriving in the Bay Area in 1882. Under the sponsorship of Manuel Leal, Manuel Terra and his wife, Marie Nunes-Terra, made their home in Santa Clara, Contra Costa, and Alameda Counties. The Terras purchased a plot of land in the early 1900s and built a house on the property soon after. There they milked the family cows, tended sheep, and planted hay and vegetables. At right is Manuel Terra. Below, from left to right, are Manuel Jr., Fred (in front), Mary, and Tony. Frank was born in 1907, and Mabel was born in 1912. (Courtesy Diane Kolb.)

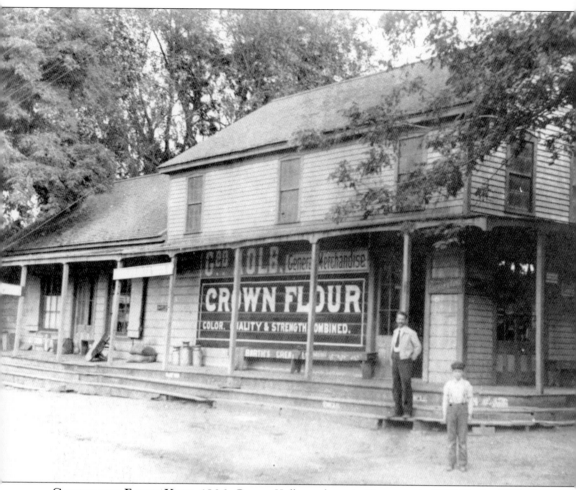

GEORGE AND EDWIN KOLB, 1906. George Kolb was born in Germany in 1867. By the 1890s, he had immigrated to the United States, arriving in Dougherty's Station some time after. George bought the Green store and ran it until 1910. He then moved his family to a ranch about a half a mile south on land he purchased from Charles Dougherty. There he raised cattle, sheep, chickens, apricots, grapes, tomatoes, alfalfa, hay, and grain. George's two sons, Edwin and Harold, were nicknamed "Mike" and "Jim" by John Green, to give them Irish names. In this 1906 photograph, George is standing in front of the store with his son Edwin. (Courtesy Kolb family.)

ELIZA DEVANY. The youngest of six children, Eliza was born in Dublin in 1862. After the death of her father, Michael Devany, in 1890, she married John W. Butterworth, a police officer in San Francisco, in 1891. She became an eyewitness to history on April 18, 1906, when the famous earthquake struck. At the time, she was two months pregnant with her fourth child. (Courtesy Eugene Lynch.)

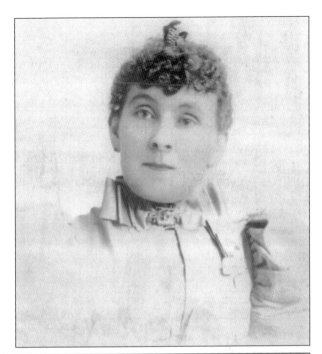

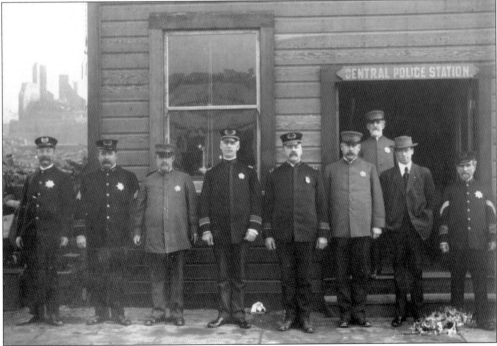

SAN FRANCISCO POLICE STATION IN 1906. Standing on the far left, John Butterworth, husband of Eliza Devany-Butterworth, poses with his fellow police officers after the San Francisco earthquake struck on April 18, 1906. These men typified the ability of people to overcome tremendous setbacks, noted by the destroyed and burned-out buildings in the background. John Butterworth is reported to have buried police records to protect them from the fires sweeping through the city, and he assisted in the dynamiting of buildings. (Courtesy Thomas Lynch.)

DOUGHERTY POSTCARD, 1907. Seen here are the Christmas wishes from Cousin Margaret to Elmer Murray during the holiday season in 1907. It is interesting to note the postmark just to the left of the stamp. Known as Dougherty's Station since 1860, on January 18, 1896, the name was shortened to just Dougherty. The town name remained unchanged until February 1908 when the name deferred to Dublin after the post office could not find someone to replace the old postmaster, Thomas Green, and closed down. As the town was commonly referred to as Dublin by the locals since the 1860s, the loss of the town's "official" name provided them an opportunity to make the switch, which they did without reservation.

Four

MOVING TOWARD MODERNITY
1908–1927

MINNIE HANSEN, C.
1910. Dressed in her finest
clothes and hat, Minnie
Hansen poses in the front
yard of her home. The
little girl in the photograph
is probably her daughter
Eleanor. Though not always
the most comfortable,
fashion conventions of
the day expected women
to dress modestly. Blouses
were always long-sleeved
and buttoned to their
necks. Skirts, likewise,
flowed all the way down
to the ground. (Courtesy
Pamela J. Reilly Harvey.)

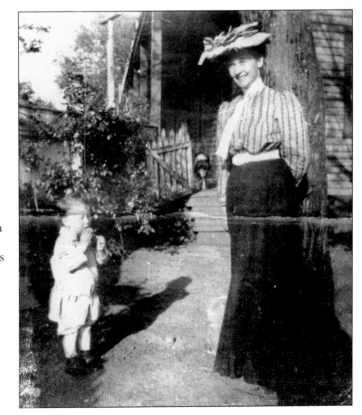

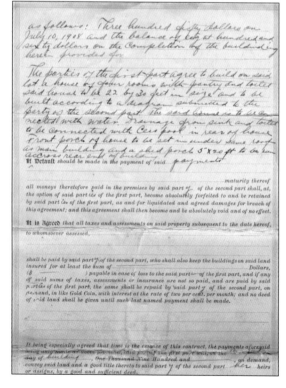

Contract

This Agreement, Made the *15th* day of *May* A. D. One Thousand Nine Hundred and *eight* Between *William Lawrence, JD Armstrong and JJ Boree all of Hayward California* the parties of the first part, and *Mrs M.E. Martin of Dougherty Alameda Co California* the party of the second part, Witnesseth, that the said parties of the first part, in consideration of the sum of *Fifty* Dollars, to *them* in hand paid by the said party of the second part, the receipt whereof is hereby acknowledged, and of the payment to *them* in United States Gold Coin of the further sum of *Twelve hundred ten* Dollars, hereinafter agreed to be paid, by the said party of the second part, to said parties of the first part,

ha*s* agreed and do hereby agree to sell and convey to said parties of the second part, *their* heirs and assigns, all th*e* certain piece or parcel of land, situate, lying and being in the *Township of Eden* County of *Alameda* and State of *California* known and described as follows, to-wit:

Lot No. 13. as said Lot is delineated and so designated on a certain map entitled "Map of the Bay Tree Tract Eden Township Alameda Co. Cal. Filed in the office of the Recorder of Alameda Co. April 20. 1908.

MARY MARTIN HOUSE CONTRACTOR AGREEMENT, 1908. Building a home in the early 1900s was much more of an arduous undertaking than it is today. At that time, people utilized the services of an architect who could design the house and then hired a general contractor to build it. Based on the contract between the builders and Mary Martin, the house was to be 22 feet by 30 feet in size, consisting of four rooms, a pantry, and an indoor toilet, a new feature of the day. (Courtesy Martin family.)

as follows: Three hundred fifty dollars on July 10, 1908 and the balance of eight hundred and sixty dollars on the Completion of the building herein provided for

The parties of the first part agree to build on said lot a house of four rooms with pantry and toilet said house to be 22 by 30 feet in size and to be built according to a diagram submitted to the party of the second part the said house is to be connected with water. Drainage from sink and toilet to be connected with Cess pool in rear of house Front porch of house to be set in under same roof as main building and a shed porch 5 x 20 ft to be run across rear end of building

If Default should be made in the payment of said *payments*

maturity thereof all moneys theretofore paid in the premises by said part of the second part shall, at, the option of said parties of the first part, become absolutely forfeited to and be retained by said parties of the first part, as and for liquidated and agreed damages for breach of this agreement; and this agreement shall then become and be absolutely void and of no effect.

It is Agreed that all taxes and assessments on said property subsequent to the date hereof, to whomsoever assessed,

shall be paid by said part of the second part, who shall also keep the buildings on said land insured for at least the sum of Dollars, ($) payable in case of loss to the said parties of the first part, and if any of said sums of taxes, assessments or insurance are not so paid, and are paid by said parties of the first part, the same shall be repaid by said party of the second part, on demand, in like Gold Coin, with interest at the rate of two per cent. per month; and no deed of said land shall be given until such last named payment shall be made.

It being especially agreed that time is the essence of this contract, the payments aforesaid being any made at times provided, said parties of the first part will, on the day of building, One Thousand Nine Hundred and , on demand, convey said land and a good title thereto to said part of the second part *her* heirs or assigns, by a good and sufficient deed.

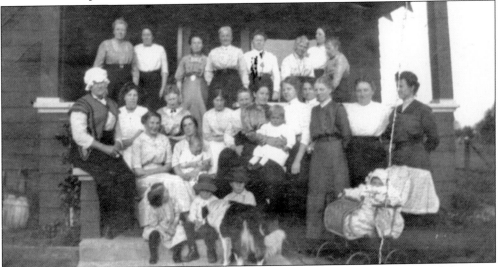

H. C. THERKELSEN

General Blacksmith
Wagon-maker and Horse-shoer

Jobbing and Repairing of all Kinds
Guaranteed and at Moderate Prices

Aost. No._____
File No._____

DUBLIN, CAL., *Nov 26* _____ 1910

In Account with _D Je_____

S/2	17	4	Shoes		1	50
"	8	2	Shoes			75
Oct	24	2	Shoes			75
Nov	26	2	Shoes			65

Paid Nov 26 1910 $3 65

H C Therkelsen

THERKELSEN BLACKSMITH RECEIPT, 1910. This receipt is a symbol of a way of life not long for this world. Even though a number of farms still surrounded Dublin, requiring the services of a blacksmith would soon be less and less in demand. With the arrival of the automobile age only a few short years away, no longer did people use wagons or horses to get around. Instead, they opted for modern transportation conveniences like bicycles or cars. (Courtesy Therkelsen family.)

MARY MARTIN HOUSE AND HANSEN FAMILY, C. 1911. Mothers, grandmothers, and daughters from the Dublin area pose for a photograph on the front porch of Mary Martin's home. Often for the purpose of afternoon tea or sewing quilts for a family in need, these kinds of functions served as a means for women to reconnect with each other. It also gave them a chance to get away from the pressures of home and enjoy one another's company without fear of prying or disapproving ears. (Courtesy Hansen family.)

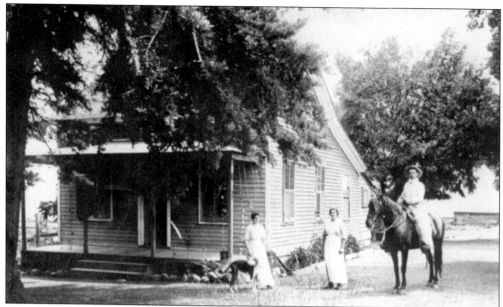

FALLON-TEHAN HOUSE, C. 1912. Built in the mid-1850s, the Fallon house was constructed from redwood trees cut from the Moraga Valley. With the assistance of a ship's carpenter, Jeremiah Fallon helped in the construction of his house. When the well near the house did not produce enough water, Jeremiah dug another well near the foot of the hills. It had a steady supply of water but was too far from the house. Since he couldn't move the well, he moved the house. Jeremiah put logs under the foundation, made axles from the ends of logs, and used wheels from a Mexican carreta. With the help of six-eight yoke of oxen, he pulled his house across the field. From left to right are Alrene Stuart Massey, Veronica Hilton Kiefer, and Dan Tehan. (Courtesy Fallon family)

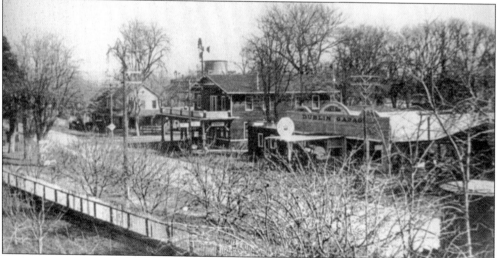

DOWNTOWN DUBLIN, 1913. This 1913 photograph gives a bird's-eye view of downtown Dublin as it stood just prior to the start of World War I. Paved roads, electrical lines, an auto repair shop, and road signs have given this quiet town of a few hundred an almost modern look as it began to distance itself from its agrarian past. Flanked by telephone poles and trees growing on both sides of Lincoln Highway, the Amador Valley Hotel and Dublin Garage are easily the most identifiable structures featured.

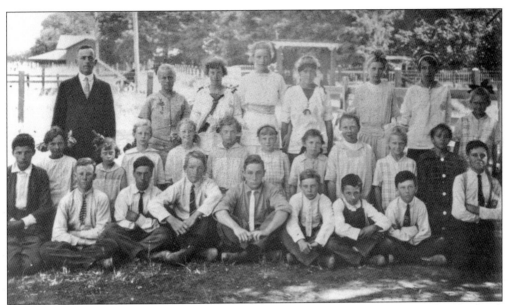

UPPER GRADES MURRAY SCHOOL, 1913–1914. Pictured here are, from left to right, (first row) Manuel Avilla, Rudy Banke, Fred Terra, Roland Oxsen, Harold Kolb, Chris Nissen, Manuel Avilla, George Hansen, and Herman Dobbel; (second row) Florence Dutra, Margarite Smith, Ella Orloff, Annie Orloff, Olga Hutto, Mabel Groth, Laura Dobbel, Meta Therkelsen, Selma Andersen, and Dolores Dutra; (third row) ? Green (teacher), Alma Groth, Mae Smith, Martha Koopmann, Anna Hutto, Emma Koopmann, Lena Dutra, and Helen Andersen.

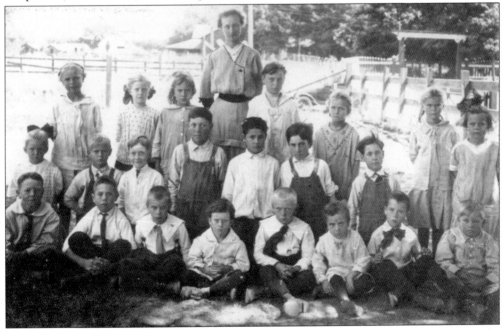

LOWER GRADES MURRAY SCHOOL, 1913–1914. The children here, like so many others over the years, undoubtedly spent many carefree hours during lunches or afternoon recesses playing the schoolyard games of their time, including Anti-I-Over, Cross the Line, Dare Base, Pump Pump Pullaway, Kick the Can, marbles, Jack Knife, and Shinney with Tin Can.

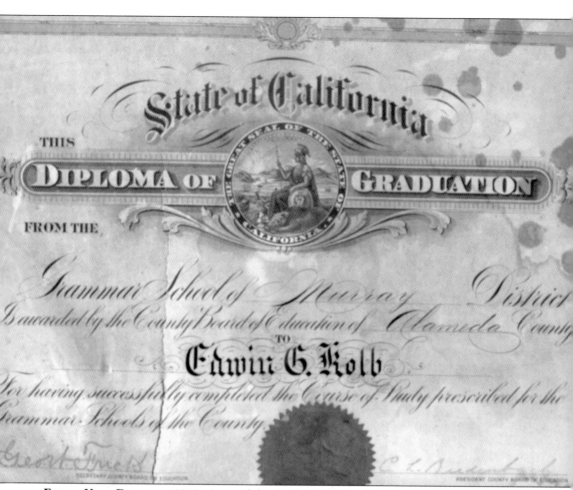

EDWIN KOLB DIPLOMA, 1913. A proud day for the Kolb family, Edwin graduated from Murray School in 1913 after eight years of hard work. Now that he had finished his studies, Edwin was expected to assume greater responsibilities in the family and work for his father, George Kolb, at the general merchandise store formerly owned by John Green. (Courtesy Kolb family.)

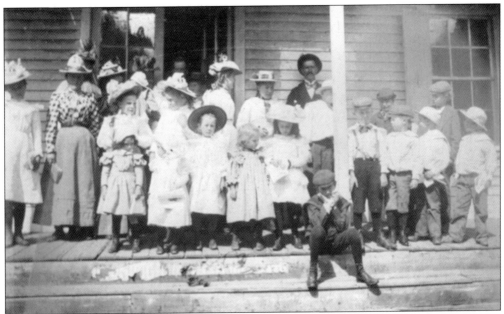

GREEN STORE LIBRARY EXTERIOR, 1914. The back portion of the Green store, now run by the Lawrence family, was converted into a library. This might have never happened, however, without the efforts of Mary Barmby. In 1910, she became Alameda County's first regional librarian. Mary was dedicated to the task of getting books out to the people, and in the next four years, she built libraries all along the East Bay. In 1914, it was Dublin's turn. So auspicious was the occasion that many of the town's people came to be a part of the heralded event. (Courtesy Leo Reimers.)

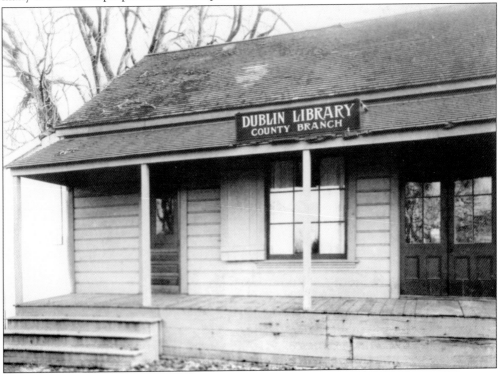

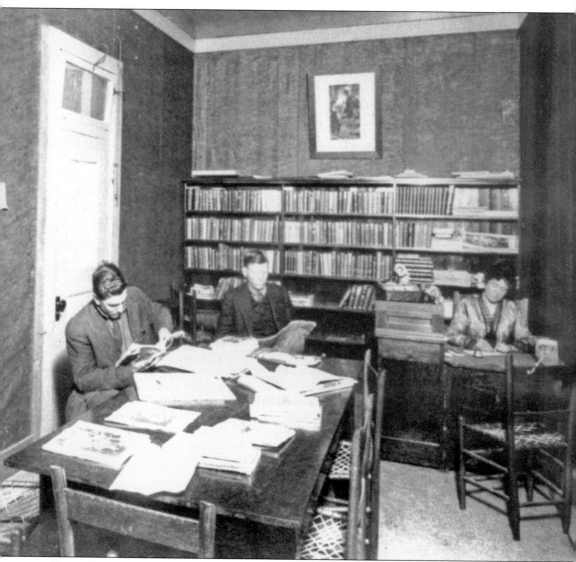

Green Store Library Interior. Before the library opened, residents had no choice but to go to the Carnegie Building in downtown Livermore if they wanted to check out a book. Traveling by foot or on horseback, it would take a person the better part of the day to traverse the eight miles there and back. When Mrs. ? Lawrence resigned as the library attendant in 1915, many other women, usually store owners' wives, oversaw the operation for the next 40 years. Circulation had begun to decline in 1943 and reached a low in 1948 when Mrs. ? Blade resigned. The library finally closed that year when the Donohue family sold the store. Harold Kolb is sitting on the left, and it is probably Mrs. John Cronin sitting at the desk on the right.

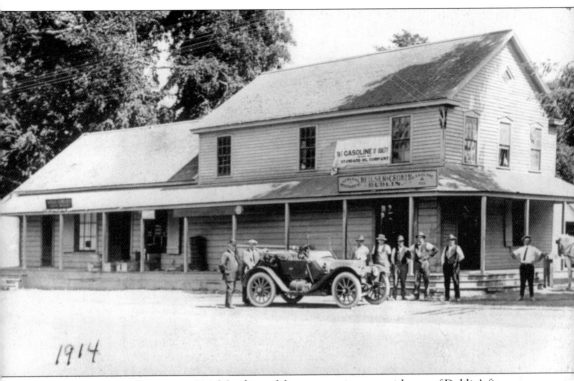

1914

GREEN STORE AND LIBRARY, 1914. Members of the community pose with one of Dublin's first cars in 1914. With the Green store now under the ownership of Nielsen and Cronin, they recognized the opportunity afforded them along the old Lincoln Highway, reflected in the signage behind them, selling automotive products like gasoline and motor oil. In an odd twist of fate, a symbol of Dublin's past, a horse and wagon, are seen in front of the store on the far right.

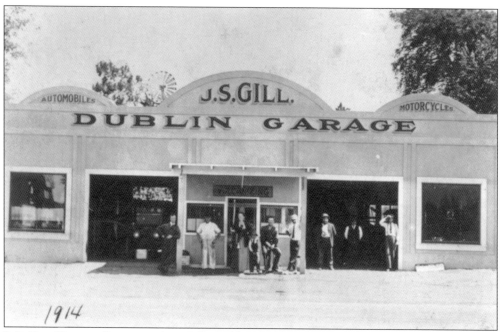

J. S. GILL DUBLIN GARAGE, 1914. Gill's Dublin Garage was situated on the south side of Dublin Boulevard, next to the Amador Valley Hotel. Believing that a greater number of people would soon own cars, J. S. Gill likewise surmised that these same people would need the services of a mechanic.

PHOTOGRAPH TAKEN AT FLANAGAN RESIDENCE, C. 1914. Pictured here from left to right are (first row) Laddie the dog, Genevieve Nevin-Hackett (kneeling), and Rod Fallon (seated); (second row) Con Nevin, Dan Nevin, Babe Nevin, Elizabeth Nevin, Everett Nevin, and Dan Tehan. (Courtesy Pleasanton Museum on Main Street.)

JACOB HANSEN RANCH HOME. When Jacob Hansen arrived in Dublin in 1897 from Denmark, he leased a parcel of land owned by Charles Dougherty. He married Minnie Martin in 1903. Together they had six children; two died at a young age. By 1912, they had saved up enough money to buy the 250-acre plot. The Hansens raised cattle, hay, and alfalfa for more than 60 years. From left to right are Minnie Hansen, Alicia, Doris, Mary Martin, Eleanor Hansen, Jacob, and George. (Courtesy Hansen family.)

HANSEN CHILDREN, C. 1914. Standing in front of Mary Martin's home, George (left), Eleanor, and John Hansen spent many carefree days playing at their grandmother's house. But tragedy could strike a family at any time, and the Hansens were no different. Shortly after this photograph was taken, John, age six, was kicked in the head by a horse and died shortly afterward. The family was so devastated by the event that horses were never again permitted near the house. (Courtesy Hansen family.)

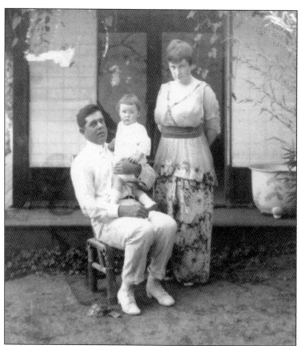

LEWIS DOUGHERTY, WIFE, MARY, AND LEWIS II, 1916. Looking like a character from one of F. Scott Fitzgerald's novels, Lewis Dougherty proudly holds his son in his arms. From left to right are Lewis Dougherty (1882–1927), son of Charles and Ida; Lewis Dougherty II; and Mary Dougherty. Taken at Ogeedankee, they are posing in front of the Japanese Tea House. (Courtesy Dougherty family.)

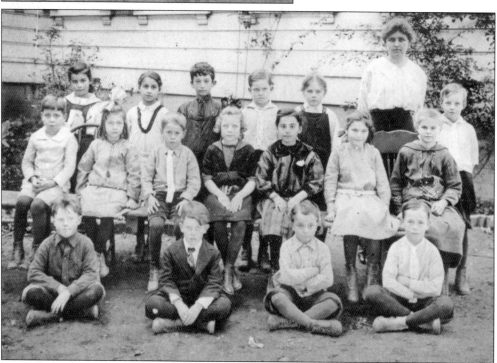

CLASS PHOTOGRAPH, 1917. Pictured here are, from left to right, (first row) two unidentified, Clarence Dutra, and Oswald Hansen; (second row) Rudolph Gerloff, Alicia Hansen, Howard Hansen, Mabel Groth, Mamie Costa, Doris Hansen, and Lillian Jensen; (third row) Mary Soares, unidentified, Jerome Costa, Stanley Andersen, John Dobbel, Gertrude Orloff (teacher), and Ed Orloff.

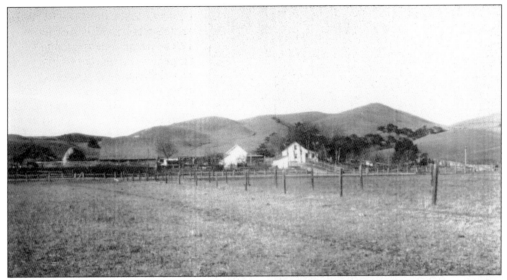

KOOPMANN RANCH, 1918. Born in 1863, William Koopmann came to Pleasanton with his parents as an infant. When his father, John, died, he took charge of the property at the tender age of 10. Farming seemed to come easy for William. Not only did he prosper as a farmer but also as a stock raiser and fruit grower. He married Dena Feldman in 1897, and they had six children. (Courtesy Koopmann family.)

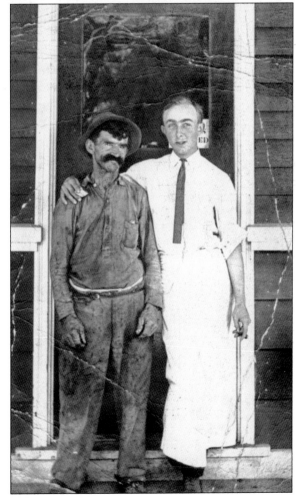

CHARLES FRY AND ERNEST REIMERS (1894–1965), 1919. Standing in front of the Reimers Hotel, Ernest (right) carries on the work started by his father, Claus. The family not only possessed a strong work ethnic, but they also had a penchant for running their businesses. Ernest held the unofficial record for giving away free drinks in his bar, thus keeping patrons there longer. An old, reclusive woodcutter who never changed his clothes, Charles Fry lived in a cabin on Mueke Ranch. (Courtesy Reimers family.)

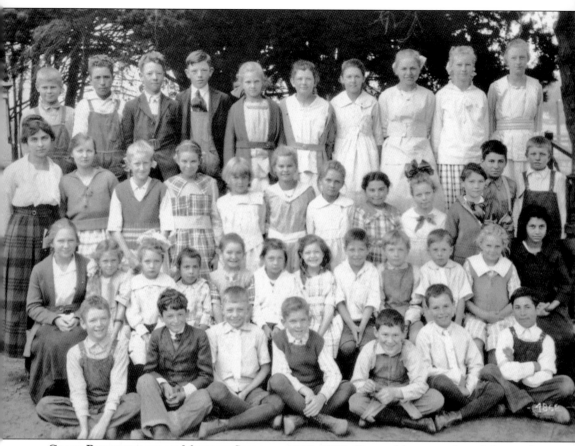

CLASS PHOTOGRAPH AT MURRAY SCHOOL, 1919–1920. Pictured here are, from left to right (first row) Tilman Nerton, Jerome Costa, Edwin Orloff, Stanley Andersen, unidentified, Oswald Hansen, and Frank Terra; (second row) Helen Andersen, Blanche Andersen, Ynez Reimers, Mabel Terra, Thelma Nerton, Alicia Hansen, Bertha Niedt, Rudolph Gerloff, John Dobbel, Howard Oxsen, Mildred Andersen, and Annie Brunn; (third row) ? Flierl (teacher), ? Chambers (teacher), Dagmar Orloff, Ida Nerton, Avis Andersen, Lillian Jensen, Mildred Dobbel, Mamie Costa, Mabel Groth, Doris Hansen, George DeAvila, and Erwin Oxsen; (fourth row) Rasmus Jensen, Joe Tiago, Victor Banke, Everett Nevin, Selma Andersen, Genevieve Nevin, Laura Dobbel, Christine Jensen, Ella Orloff, and unidentified.

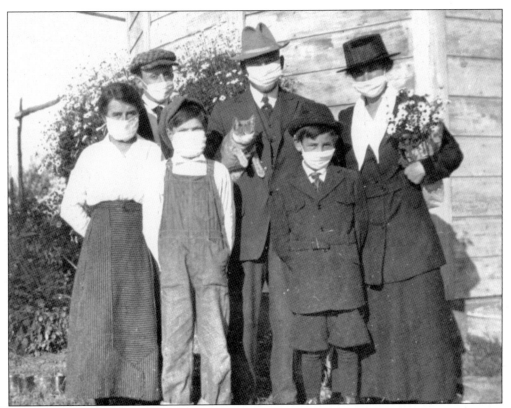

FLU EPIDEMIC, 1920. In the fall of 1918, when the Great War in Europe was winding down, an illness, first believed to be as benign as the common cold, began to develop in pockets across the globe. The influenza of that season, however, was far more deadly than any cold. In the two years that this scourge ravaged the earth, a fifth of the world's population was affected. By 1919, the influenza pandemic killed between 20 and 40 million people. So great was the fear of contracting this deadly virus that people as far away as Dublin took whatever precautions they could to protect themselves.

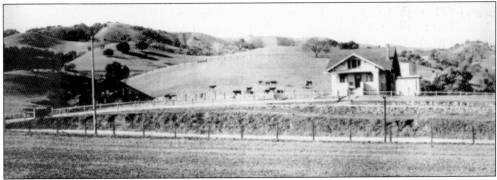

MOLLER RANCH, C. 1922. Long known for their success in the cattle business, the Mollers not only owned vast herds of cows on their property along Foothill Road, but they also butchered the animals in their own meatpacking plant and sold cuts of beef directly to the people. The elder Moller came around twice a week in a van to his customers. Since few families enjoyed the benefits of refrigeration in homes at this time, they usually cooked the meat on the same day. (Courtesy Moller family.)

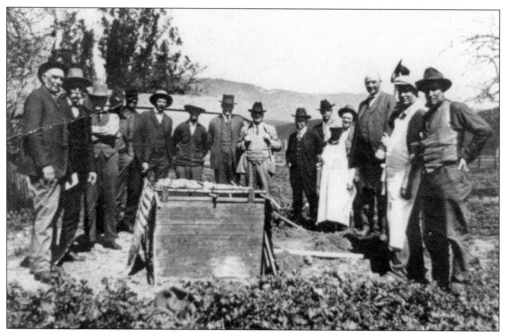

STAFFORD RANCH, 1923. Swapping stories and spending time together with old friends, many of Dublin's pioneer families enjoyed coming together and sharing in the bonds that had formed years before. From left to right are ? Stafford, Rod Fallon, W. J. Martin, Dick Martin, Frank McCormick, W. J. Tehan, Tom Nevin, Vance Saullie, Con Nevin, Jissa Brite, Dennis Nevin, Frank Tusciano, Pete Hoare, Lee Wells, and J. R. Cronin.

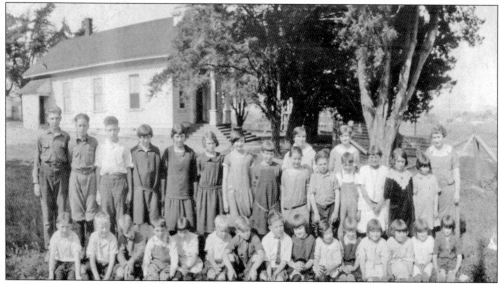

CLASS PHOTOGRAPH, 1924. Pictured here are, from left to right, (first row) Leo Jensen, Harold Moller, three unidentified, Lloyd Moller, Russell Andersen, Marvin Long, Evelyn Long, two unidentified, Helen Cronin, Frances Cronin, unidentified, and Henrietta Woods; (second row) Raymond Hansen, Howard Hansen, Rudolph Gerloff, Ynez Reimers, Ida Mills, Blanche Andersen, Alicia Hansen, Grace Reimers, Eleanor Hansen, Gwendolyn Debold, Billy Niedt, unidentified, Bertha Niedt, unidentified, Julia Weeds, unidentified, and Gertrude Cassin (teacher).

FRANK TERRA IN HIS FOOTBALL UNIFORM, C. 1924. Frank Terra was born on the family farm in Dublin in 1907. He attended Murray School, graduating in 1921. He used to ride his horse to Livermore High School, the only high school in the valley until Amador Valley High School opened in 1923. Frank wanted to go onto college after graduating in 1925, but his father needed him to work on the ranch. He married Mary Ornellas in 1930. Not only did Frank Terra run the family dairy, but he also grew alfalfa, hay, barley, tomatoes, cucumbers, and sugar beets. In addition, he raised turkeys, chickens, and ducks. In the mid-1950s, Frank Terra was elected to the Murray School Board of Trustees. (Courtesy Terra family.)

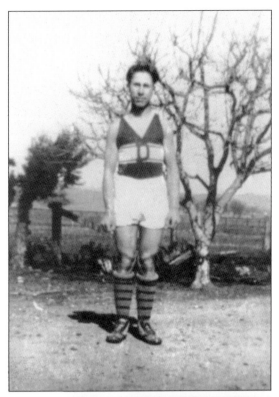

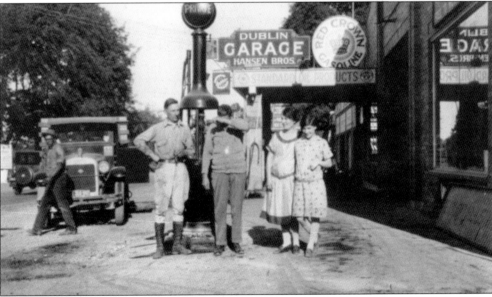

HANSEN BROTHERS GARAGE, C. 1925. The Dublin Garage, formerly owned by J. S. Gill, is now run by the Hansen brothers. The man posing on the left is Arthur Hansen. Standing next to him is Felix Ferrero. Dressed in the style of the times, Felix's wife, Hazel, and daughter were freer to express themselves through fashion and hairstyles during the flapper era. A dream for any motorist today, the price of gasoline listed just below the Standard Oil Products sign is 21¢ per gallon. (Courtesy Hansen family.)

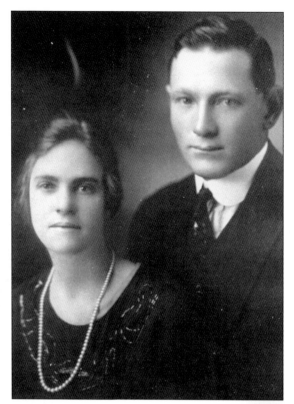

TILLIE, TOM, HAROLD, AND ROBERT NIELSEN, C. 1926. Tom Nielsen married Tillie Carstensen in 1921. When they returned from their honeymoon in Hawaii, many of their neighbors welcomed them back, curious to hear about such an exotic and far-away place. They had two sons—Harold (below left), born in 1921, and Robert, born in 1926. The Nielsens ran a farm on the land they leased from James Witt Dougherty II. In time, they had saved enough to buy it outright from him. A believer in education, Tom Nielsen was one of the founders of the Murray School District. The Nielsens continued raising cattle and sheep in the ensuing years, along with growing tomatoes, hay, and grain. Robert expanded the family business and created the TN Cattle Company, Inc., one of the largest cattle producers in the state today. (Courtesy Roxanne Nielsen.)

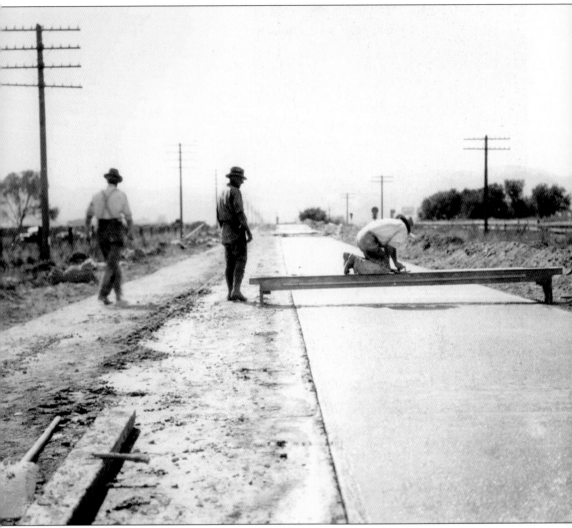

Paving Highway 50, 1927. The beginning of the interstate highway system traces its roots to 1895. After surveyors went to every county in the state, their recommendations became the foundation for the highway system that exists today. The passage of the "Convict Labor Law" in 1915 authorized the use of convict labor for highway construction. Subsequently, many of the roads were constructed by convict labor for years to come. The 1909, 1915, and 1918 bond acts provided funding for construction, while the Federal Aid Highway Act of 1925 created a nationwide system of standardized routes. By 1927, the realization of a modern highway system finally reached Dublin. Helping to bring the town into the modern age, this photograph shows that the work of trawling the cement for Highway 50 still had to be done by hand. (© Copyright 1927 California Department of Transportation.)

DONNA KOLB. Donna Kolb, here a young child, feeds one of the sheep she was responsible for on her family's property. Many of the children who grew up on the family farms were expected to do their share of the work. Not only did they feed the animals, but they also worked the fields, harvested crops, and prepared family meals. Though the hours spent each day helping to keep the farm running were difficult, sharing in the burden kept family ties strong. (Courtesy Kolb family.)

CHARLES DOUGHERTY, c. 1927. Still wearing his trademark moustache in a larger-than-life manner, this is how Charles Dougherty appeared in his later days. He died at the age of 88 in 1932, just one year after his wife, Ida. He is buried in the Dougherty family plot in Dublin Pioneer Cemetery. (Courtesy Dougherty family.)

Five

PROSPERITY AND SACRIFICE
1927–1940

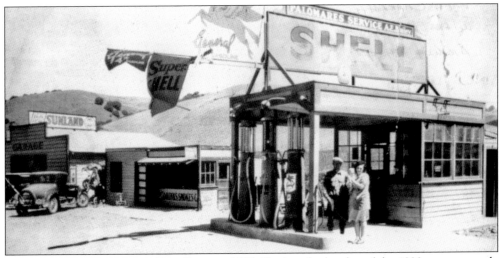

ROBERT, CHARLOTTE, AND RON BAILEY, 1927. During the heyday of the 1920s, many people were willing to take a chance on the future and lay claim to their piece of the American Dream. Robert Bailey, Charlotte, and son Ron were no different. Situated on Old Dublin Road, the Baileys built the Shell station, market, and garage, seen here behind them. With the promise of greater numbers of travelers driving on the newly constructed Highway 50, their prospects for the future seemed all but certain. (Courtesy Bailey family.)

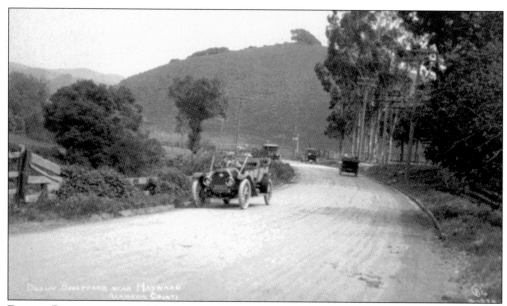

DUBLIN BOULEVARD NEAR HAYWARD, C. 1927. Even though the national highway system was fast connecting cities and towns along major routes, most of the roads in many parts of the state, including the Dublin area, were nothing more that dirt streets, created by horse and rider decades before. With the coming of the automobile, a good number of these same roads were widened to accommodate the increase in traffic. (Courtesy Bancroft Library, University of California, Berkeley.)

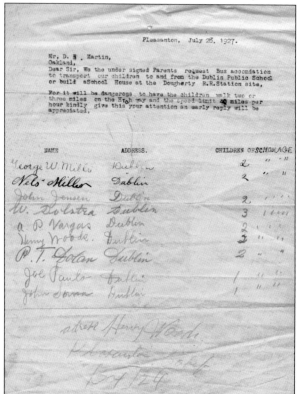

SCHOOL BUS PETITION, 1927. With the completion of Highway 50, parents had become concerned about the safety of their children as they traveled to and from school. As their petition states, they demanded the district seat in Oakland to either provide bus service for their children or build a schoolhouse at the Dougherty Railroad Station site. Their petition must have worked. Hans Therkelsen constructed the first school bus on the frame of a Ford Model T truck. It is interesting to note that, by 1927, everyone seems to have accepted Dublin as the name of the town.

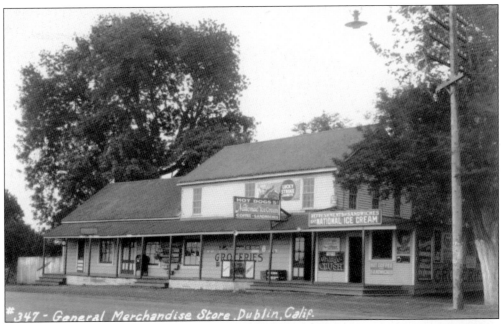

#347 - General Merchandise Store, Dublin, Calif.

GREEN STORE. In keeping with the entrepreneurial spirit developed by John Green in the 1860s, new owners continued selling general merchandise to passersby. Hotdogs sold for 5¢. People could also purchase groceries, ice cream, coffee, sandwiches, cigarettes, and soda. The Green store also served as an informal post office, noted by the number of mailboxes hung on the wall to the left of "Groceries" sign.

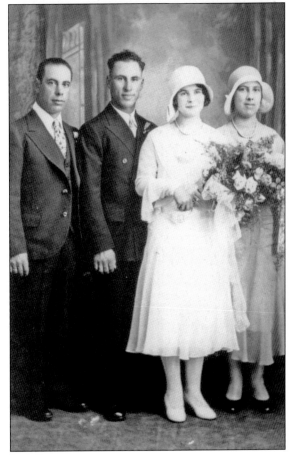

TERRA FAMILY WEDDING, 1930. Frank Patrick Terra and his wife, Mary Clara Ornellas, are pictured here on their wedding day in 1930. Frank and Mary had six children—three girls born on the farm and three at St. Paul's Hospital in Livermore. The Terra girls did their part on the farm when they were older, helping herd sheep from the Dublin Ranch to their property on San Ramon Road. They also helped with household chores, milked the cows, drove the tractor, put hay in the barns, moved irrigation pipes, and canned fruit. The Terras enjoyed spending time with their relatives during the holidays and other family gatherings. (Courtesy Terra family.)

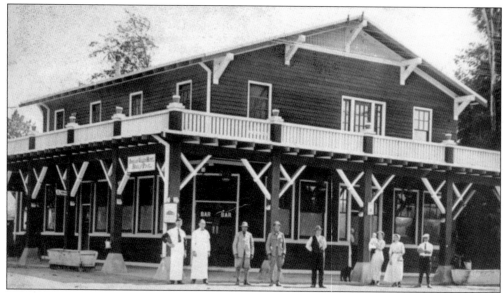

AMADOR VALLEY HOTEL, C. 1930. Pictured here is the Amador Valley Hotel as it looked in the 1930s. When Art Reimers took over as proprietor, it became known as the Reimers Hotel. The men on the left are Mike Mondo and Art Reimers. The person on the far right is Walter Reimers.

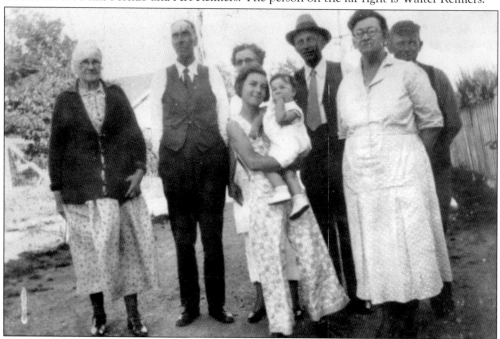

HANSEN FAMILY, EARLY 1930S. Finding themselves in the throes of the Great Depression, families like the Hansens were forced to do whatever they could to stay afloat financially. Minnie Hansen grew a whole assortment of fruits and vegetables in her garden. Even though money was scarce, people still had to eat. The Hansens often traded or bartered milk, eggs, cheese, and other goods for things they needed to keep the farm going. Pictured from left to right are Mary Martin, Jake Martin, Minnie Hansen, Ruth, Patty Lou, Fred, Christine, and Walsh. (Courtesy Hansen family.)

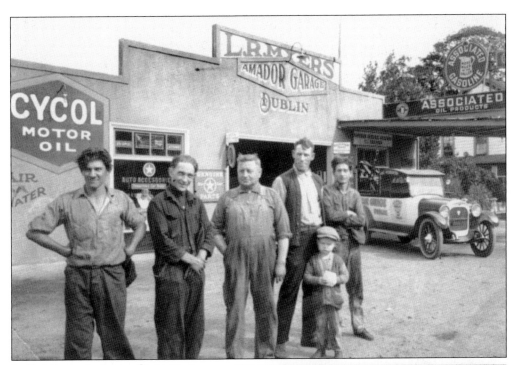

L. R. Myers Amador Garage, c. 1930. Capitalizing on one of Dublin's biggest source of revenue—the passing motorist—entrepreneurs like L. R. Myers opened up a gas station and garage along Highway 50. With a steady stream of cars passing through town on a regular basis, he could expect to make a fairly good living for the times. The boy standing in front is LeRoy Myers.

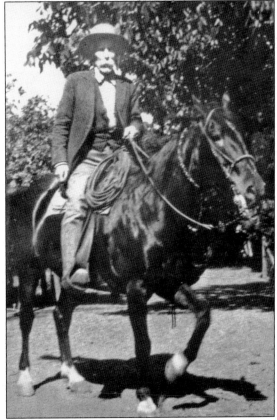

Roger Fallon (1853–1932), c. 1932. Known as the grand old man of Dublin, Roger Fallon was well versed in the ways of a farmer, having grown up on a farm. The son of Jeremiah Fallon, he became the overseer of the Dougherty Ranch. The plaque beside his grave read, "Renowned for his honesty and integrity and proficiency with the riata [rawhide rope] which was sometimes up to 70 feet in length." This photograph was taken not long before he died. (Courtesy Fallon family.)

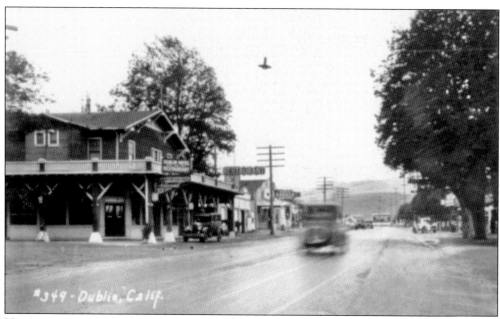

HIGHWAY 50, C. 1932. Pictured here is another scenic day along Highway 50 as it cut through downtown Dublin. However, this was not to last. Over the next two decades, federal studies and national highway acts enacted by Congress called for the creation of an interstate highway system that would create practical routes between towns and cities. Under the leadership of President Eisenhower, the Federal-Aid Highway Act of 1956 became the catalyst for the system's development. With an appropriation by Congress in 1958 for $34 billion, construction began in earnest. In the years that followed, the construction of I-580 replaced Highway 50, once the main thoroughfare between Oakland and the San Joaquin Valley.

DUBLIN HOTEL BUSINESS CARD. As this Dublin Hotel business card, printed in the 1930s, showed even people in rural communities enjoyed going out and having a good time. Under the proprietorship of Louis Brignoli, his hotel offered a menu that specialized in Italian and French cuisine. Patrons also enjoyed an evening of live music and dancing. During these same years, John Cronin held semiannual turkey raffles at the hotel.

Six

WAR AND CHANGE
1940–1960

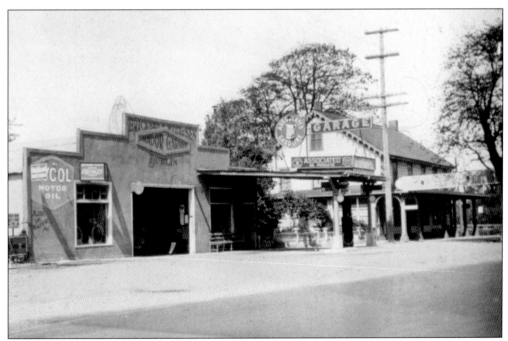

ERICKSEN AND NIELSEN AMADOR GARAGE, EARLY 1940S. Located next to the Dougherty Station Hotel, the Amador Garage was an obvious choice for a business located along the busy highway. Automobiles often stopped to fill up their tank or a mechanic made repairs to their car before moving on again. While people waited, they could walk next door to the hotel and grab a quick bite to eat.

James Witt Dougherty II (1876–1945), c. 1940. James Dougherty was the son of Ida and Charles Dougherty and the grandson of James Witt Dougherty. He is buried with his family in the Dublin Pioneer Cemetery. (Courtesy Dougherty family.)

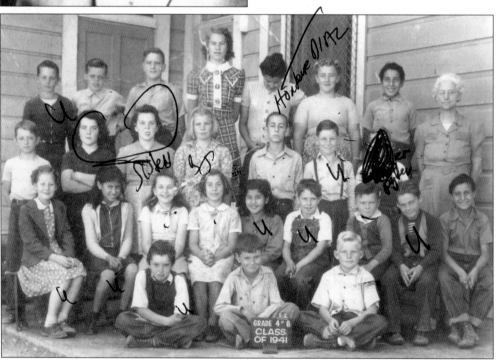

Murray School Class Photograph, 1941. Pictured here are, from left to right, (first row) unidentified, Phillip Doyle, and William Johnson; (second row) two unidentified, Betty Woods, Marion Terra, two unidentified, Jerry Paulsen, unidentified, and Alfred Edsen; (third row) Ernest Oxsen, Maxine Sturm, Joanne Sturm, Betty Johnson, George Santos, unidentified, and William Kolb; (fourth row) unidentified, Dennis Lima, Allen Hill, Edith Andersen, Hortense Dias, Arlene Paulsen, Charlie Edson, and Bertha Castersen (teacher).

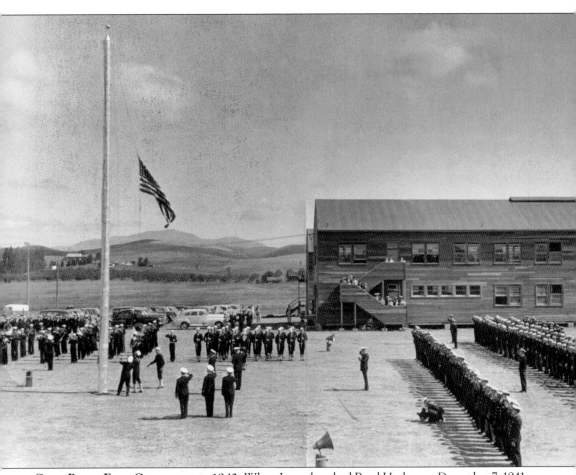

CAMP PARKS FLAG CEREMONY, C. 1943. When Japan bombed Pearl Harbor on December 7, 1941, the United States suddenly found itself mired in the middle of global conflict it was not prepared to fight. In particular, there was a vast shortage of bases to train the millions of new recruits. In response to the need, every branch of the military began constructing installations all over the country; one such place was Dublin. Commissioned in January 1943, Camp Parks was built as a navy base. Home to the Seabees, the base could train up to 20 battalions at a time before they shipped out to the Pacific theater of operation. Their skills in constructing roads, bridges, and airports were essential to the war effort against Japan. After the war ended, the need for training new recruits ended with it. The base served a number of purposes over the years until 1964, when much of the excess property was used as a Job Corps Training Center for underprivileged youths. One of those youths became boxing's heavyweight champion of the world—George Foreman. In 1973, the U.S. Army transformed Camp Parks into a training center for reserve units, and it has been used in this capacity ever since. (Courtesy Camp Parks History Center.)

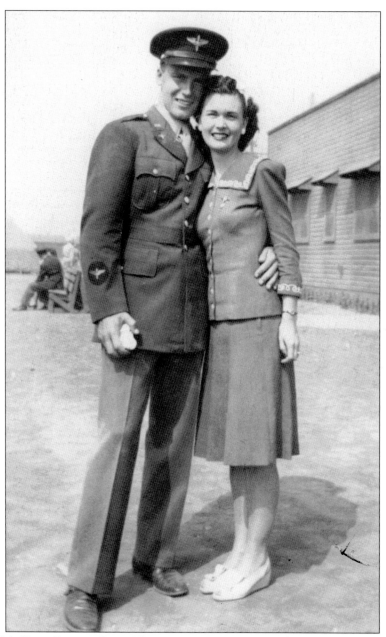

LT. JAMES McCANN JR. AND RUTH HANSEN-McCANN, 1943. This was young love that ended too soon. The daughter of Jacob and Minnie Hansen, Ruth grew up in Dublin. After graduating from Murray School in 1935, she went on to attend Amador High School, and it was there she met James McCann. The two became high school sweethearts. When Japan attacked Pearl Harbor, James answered his nation's call and joined the Army Air Corps, where he trained as a copilot for B-25 bombers before shipping out to fight the Japanese in the Pacific. But before he left, he married Ruth Hansen in February 1943. Sent to the front lines, Lieutenant McCann saw his share of combat. In November 1943, he was shot down and killed in Rabaul, New Guinea. So devastated was Ruth McCann by the loss of her young husband that she did not marry again until 1956. (Courtesy Pamela J. Reilly Harvey.)

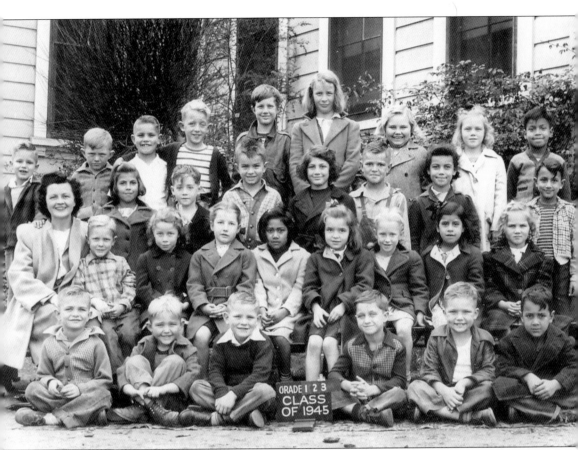

MURRAY SCHOOL CLASS PHOTOGRAPH, 1945. Pictured here are, from left to right, (first row) Willard Vale, George Selts, Jack Nebel, Irving Valentine, William Hunt, and John Boscarella; (second row) Jay Martin Jr., Christine Batchelor, Carol Kolb, Joanne Watanabe, Jeanie Santana, Betty Ann Powell, unidentified, and Sarah Thompson; (third row) Virginia Barthell (teacher), Patsy Terra, Bill Donahue, Alan Simpson, Judy Hilton, William Vale, Louise Lima, and Frank Boscarella; (fourth row) Jim Fish, Jim Bartram, Jon Nebel, George Oxsen, Howard Hilton, Lorraine Gibson, Nicky Sells, Judith Doolan, and unidentified.

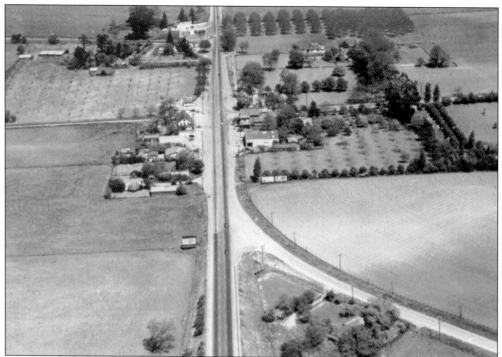

AERIAL VIEW OF DOWNTOWN DUBLIN IN THE MID-1940S. Here the original Lincoln Highway is merging with the new Highway 50. In the foreground to the right are Reimers Ranch, Kolb Field, the Hansen Brothers Garage, the Amador Valley Hotel, and John Green's store. The next set of buildings to the right on Highway 50 are the John Niedt home built by Charles Dougherty, the Greasy Spoon restaurant, the Shell station, the Dougherty Hotel, the Associated Service Station, the Bonde Garage, the Bonde home, and the Therkelsen Blacksmith Shop.

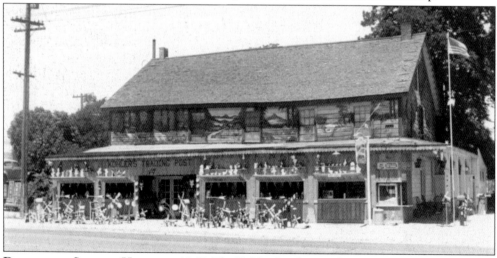

DOUGHERTY STATION HOTEL, C. 1947. The Kohler family transformed this building, no longer serving as a hotel, into a roadside stand, selling specialty items to passersby. Some of the things they sold were windmills, painted woodcarvings, Disney figures, postcards, hotdogs, ice cream, and popcorn. The flag blowing just to the right of the Trading Post shows the 48 states in the union at that time.

BUTTERWORTH—In this city Nov. 15, 1949, Elizabeth A., beloved wife of the late John W. Butterworth, loving mother of William Butterworth, Mrs. Hazel Barry, Mrs. Violet Brady, and Mrs. Angela Lynch. A native of California. A member of St. Anne's Confraternity of St. Peter's Church.

Friends are invited to attend the funeral Thursday at 9 a. m. from the chapel of the UNITED UNDERTAKERS, 1096 So. Van Ness Ave. at 22nd St., thence to St. Peter's Church, where a Solemn Requiem High Mass will be celebrated at 9:30 a. m. Interment, Holy Cross Cemetery.

ELIZA DEVANY-BUTTERWORTH 1949 OBITUARY NOTICE. Married to John Butterworth in 1891, Eliza was the mother of four children. After John's death in 1908, she lived in San Francisco until her own death in 1949. She remained a widow for 41 years, never remarrying. Eliza and John are both buried at Holy Cross Cemetery in Colma, California. (Courtesy Virginia Dold.)

FREDRICKSEN'S BARBERSHOP, C. 1949. For many Americans across the country, the local barbershop is a place for men to come together and talk about the latest news or discuss other topics of interest. Mostly it was a place where friends could sit down and enjoy one another's company. Art Fredricksen (1888–1978) is the man sitting in the barber chair. Sitting at far right is John Bonde (1855–1949).

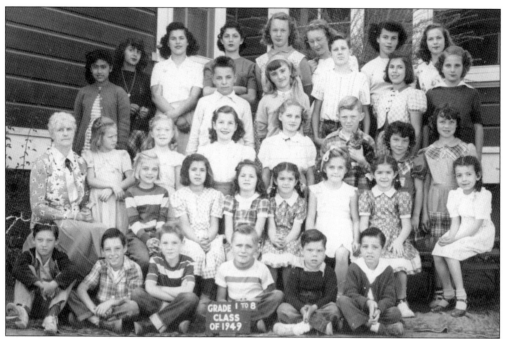

MURRAY SCHOOL CLASS PHOTOGRAPH, 1949. Pictured here are, from left to right, (first row) Allen Dutra, Dennis Dutra, Gary Larsen, Jim Hanselman, Tom Gordon, and Larry Dutra; (second row) Brenda Bartram, Marjorie Terra, Elaine Minton, Alice Martin, Alana Jones, Carol Martin, and Nancy Lima; (third row) ? Spotorne (teacher), Velma Mitton, Darlene Hendricksen, Carol Kolb, Sarah Thompson, Jim Bartram, Marlene Gordon, and Norma Gordon; (fourth row) Darrel Oswell, Patsy Hanselman, Howard Hilton, Patsy Terra, and Arlene Oswell; (fifth row) Joanne Watanabe, Joan Garcia, Dolores Terra, Judy Hilton, Lois Gibson, Lorraine Gibson, Louise Lima, and Bonnie Minton.

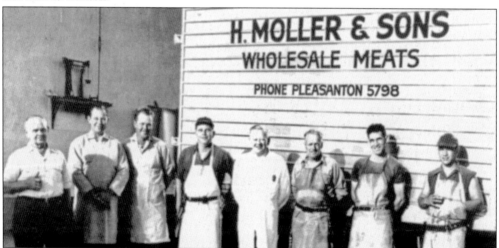

H. MOLLER AND SONS MEAT COMPANY, C. 1949. As the photograph clearly shows, this business was a family affair. The Mollers served as Dublin's butchers for many years before selling their cattle ranch in the 1970s. Pictured from left to right are Henry Moller, Harold Moller (son), Lloyd Moller (son), Roy Moller, an inspector (in white suit), and three unidentified workers. (Courtesy Moller family.)

MURRAY SCHOOL, C. 1950. This photograph shows how Murray School looked in the early 1950s. The original bell tower was removed in 1940 and is believed to have been melted down to help in the war effort. The state gave the building to the Dublin Heritage Preservation Association (DHPA) in 1975 to make way for the widening of I-580. The old school moved to its present location on Donlon Way. Through the efforts of the DHPA, they added a new bell tower in 2001. Pictured are, from left to right, Lynn Moller, John Banke, and Caroline Wing. (Courtesy Laurine Wing.)

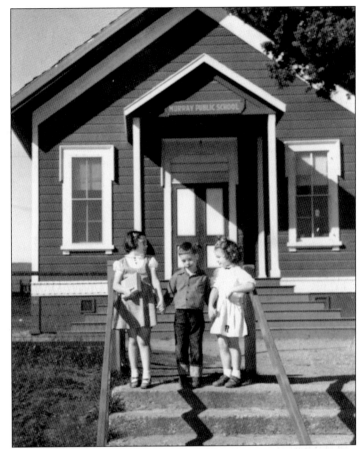

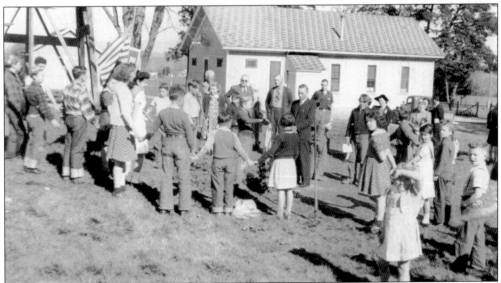

EARLY-1950S MURRAY SCHOOL. The children, teachers, and board members gather at Murray School for an outdoor ceremony. During recess, the children played games such as hopscotch, kickball, tetherball, and baseball. On rainy days, they would play games like jacks indoors.

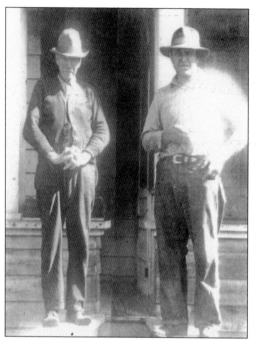

GEORGE AND JACOB HANSEN, C. 1950.
Jacob Hansen and oldest son George are standing in front of Mary Martin's home across from the main ranch house. Even though George lived in Pleasanton, he came to the ranch house every day to keep the family business going after his father died in 1952. Ruth Hansen-Reilly, her husband, John Reilly, and three children lived on the property until the late 1960s. Like so many other ranchers, the Reilly family sold their property when developers came calling. The new owners bulldozed the farm and built condominiums on the property. (Courtesy Hansen family.)

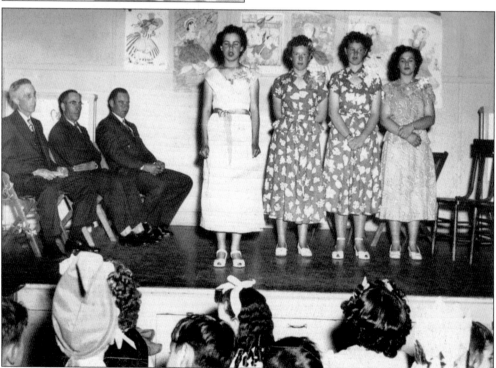

MURRAY SCHOOL TRUSTEES AND GRADUATES, 1950. When Murray School opened its doors in 1856, little did those pioneer families realize that students would be still using the same building a century later. Still a community of several hundred people, this graduating class produced only four students. Pictured are, from left to right, H. W. Kolb, Frank Terra, Harold Moller, Dolores Terra, Lorraine Gibson, Lois Gibson, and Louise Lima.

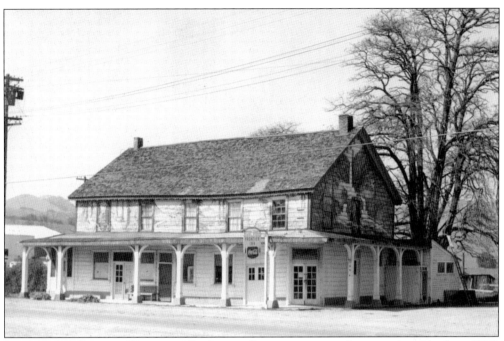

DOUGHERTY STATION HOTEL, 1953. In an effort to spruce up the aging hotel built in 1862, Ruth Forbes's father painted murals on the second floor, although the signs of age are still clearly evident. It was a vain effort at best, however. In July 1956, fire destroyed the old hotel. The official cause of the blaze was defective wiring.

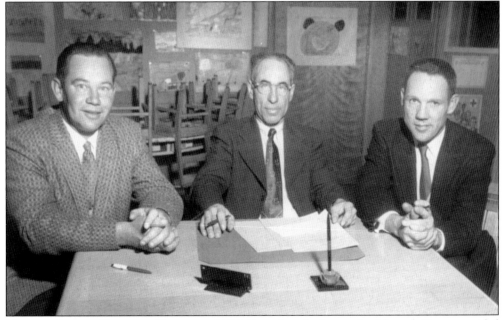

MURRAY SCHOOL BOARD OF TRUSTEES, 1954. Even though the seat for Alameda County resided in Oakland, council members recognized that schools could be administered more effectively if they were run at the local level. Pictured from left to right are Harold Moller, Frank Terra, and Russ Larsen. (Courtesy Evelyn Moller.)

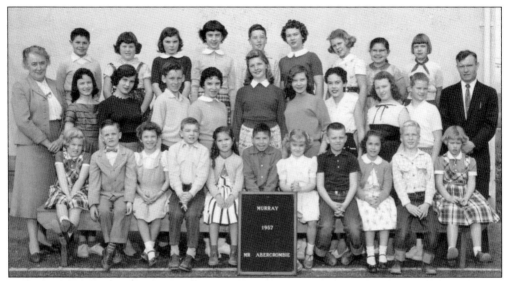

MURRAY SCHOOL CLASS, 1957. Pictured here are, from left to right, (first row) Christine Kolb, Ronald Duarte, unidentified, Ronald Wing, two unidentified, Janice Miller, John Moller, Marlene Mattos, Craig Miller, and Kathy Kolb; (second row) Peggy Purtyman, Sandy Black, unidentified, Sherry Lafayette, Dorothy Hucke, Lynn Moller, unidentified, Joan Simpson, and Marcia Lydiksen; (third row) three unidentified, Alma Thompson, unidentified, Johnny Banke, Carolyn Wing, Patsy Hucke, unidentified, Becky Bartram, and ? Abercrombie (teacher).

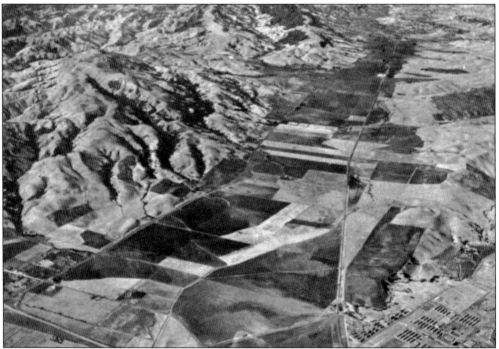

DUBLIN AERIAL VIEW, 1959. Despite the years of growth taking place in many Bay Area cities over the last 40 years, Dublin remains largely untouched. With a population of only 250 people, this aerial photograph clearly shows many of the family farms still growing crops or raising cattle, just as they have done for the past century.

Seven

PATH TO A CITY
1961–1982

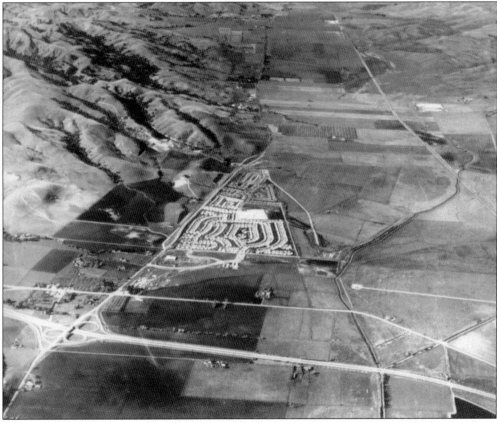

DUBLIN, 1961. What a difference two years can make. This photograph of the same area as the one taken in 1959 clearly shows a dramatic change. Dublin's first modern housing tract has already been completed, and just to the south, the 580/680 interchange is in its final stages of construction. Known as a sleepy town to the west of Oakland, Dublin's population skyrocketed when it opened the floodgates of land development, going from a mere 250 people in 1960 to about 7,000 by 1965. Three years later, a newspaper reporter would lament, "San Ramon Village near Dublin, pastoral and void of homes a few short years ago, is a dramatic example of the changing California landscape . . . for housing in the Bay area is becoming a scarce commodity, and the 20,000 current residents are but the forefront of another San Fernando Valley encircling Pleasanton in the south and Livermore in the east." (Courtesy *Oakland Tribune*.)

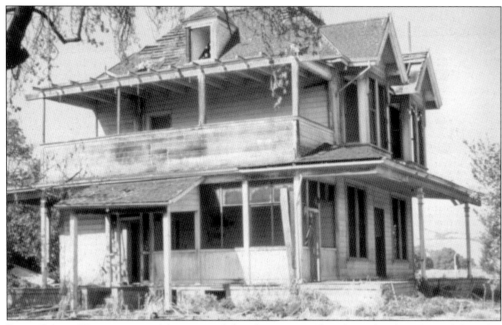

JOHN GREEN HOUSE, 1967. After years of abandonment and neglect, the glory days of the John Green home had long since past. In the 1960s, Dublin began the process of transforming itself from an agrarian economy to that of a modern urban center. This photograph stands as a symbol of people's belief that, in order for Dublin to embrace a better future for itself, treasures such as these needed to be cast aside. Not long after this picture was taken, a bulldozer flattened the house to make way for a Shell service station.

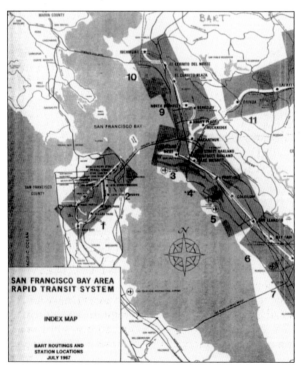

BAY AREA RAPID TRANSIT, 1967. The Bay Area Rapid Transit (BART) system was first proposed in 1946 by Bay Area business leaders concerned with increased congestion in the region. After years of reviews and planning, construction officially started on June 19, 1964, and regular passenger service began on September 11, 1972. Pres. Richard Nixon rode the system to help usher in the state-of-the-art rail line. But as this map of BART shows in 1967, the proposed stations do not include stops anywhere near Dublin. As the years went on, however, and Dublin continued to grow in population, the need for a branch line to Amador Valley became inevitable. In 1997, a 13-mile extension line to Dublin/Pleasanton finally opened for service. (Courtesy Dublin Library.)

DON HO CHURCH FUND-RAISER, C. 1968. In the late 1960s, Don Ho was coming into his own as an entertainer. A featured headliner in Las Vegas, Lake Tahoe, Chicago, and New York City, he entertained audiences with songs like *Tiny Bubbles, I'll Remember You,* and *With All My Love.* While playing in the Circle Star Theater in San Carlos, an acquaintance of his asked him to perform at the "O'Brien Goes Hawaiian" benefit for St. Raymond's Church. Because of bold strategies such as this, the town raised the money needed to refurbish the church to its original condition.

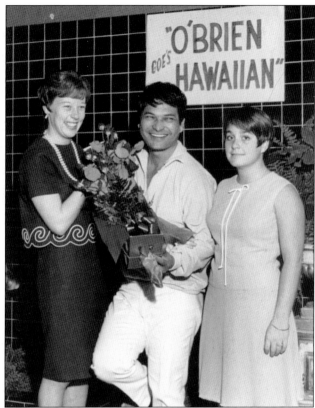

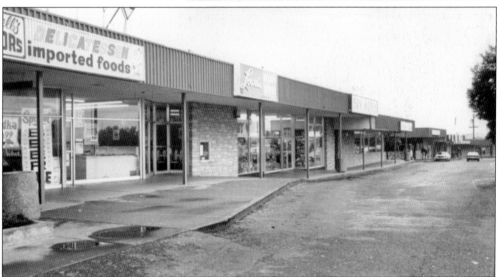

DRUG CITY SHOPPING CENTER. As the population in Dublin rose in the 1960s, investors were willing to take a chance on constructing the town's first shopping center. Named Drug City, the center included Romley's grocery store, a barbershop, a beauty salon, a drugstore, and a thriving social hotspot called the Dublin Corral. For 25 years, old-timers and new residents alike would frequent this restaurant. The Dublin Community Club, Rotary Club, and other civic groups used to meet there as well.

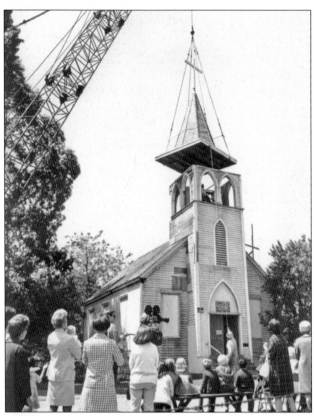

ST. RAYMOND'S CHURCH RENOVATIONS, 1970. In 1968, the Roman Catholic bishop of Oakland donated the land that St. Raymond's Church had stood on for more than a century to the Livermore Valley Historical Society. The first directors were George Lydiksen, Russ Andersen, Rudolph Banke, Roy Niedt, Walt Reimers, Charles Dougherty, and John Cronin. After years of neglect, the board of directors and other concerned citizens decided they could not let one of their most cherished buildings from the past fall prey to the ravages of time. As these photographs show, repairs to the church were extensive. A crane placing the bell tower back in place became a media event, with a film crew covering the delicate operation in front of a crowd of onlookers and supporters.

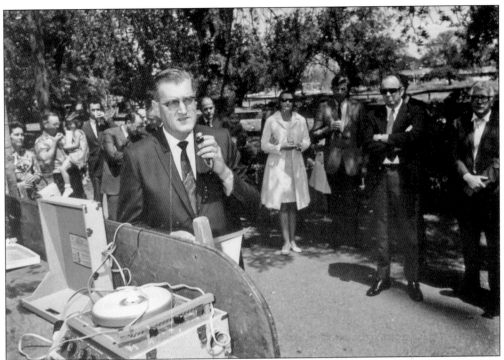

CHURCH DEDICATION, HERB HAGEMAN, 1970. The people of Dublin celebrated the unveiling of St. Raymond's Church after renovations. Surrounded by many supporters, local historian Herb Hageman officiated the proceedings.

ST. RAYMOND'S CHURCH, 1970. Dublin's best-known treasure, St. Raymond's Church, was restored to its former glory. After a year of renovations, people from all over the area came together for the purpose of preserving a community's spiritual heritage. Though the church no longer serves as a house of worship, its legacy stands as a testament that the past should never be discarded or forgotten. The church is now listed on the State of California's Points of Historical Interest Registry and the National Register of Historic Places.

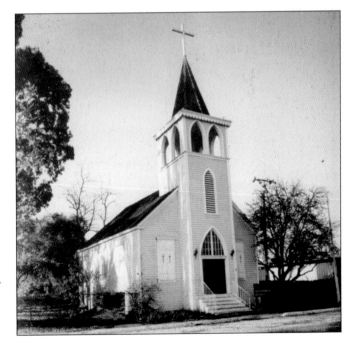

EARLY-1970S DUBLIN PARADE. For over 100 years, the people of Dublin embraced different and varied influences that have made the town what it is today. In this photograph, one cannot help but notice the person dressed in Colonial garb holding a flag from 1776. Other participants in the parade are dressed like a Native American, a cowboy, and a Mexican señorita from the past century. Social events, such as the Wool Growers picnic, Farm Bureau picnic, and the Alameda County Fair, helped maintain family and social connections. (Courtesy John D. Cronin.)

MOLLER CATTLE DRIVE, C. 1971. An anachronism from the past, the Moller ranch was one of the last working ranches in the area. Urban growth, however, continued to chop away Dublin's connection to its roots. Farmers, such as the Mollers, either died out over time or could no longer earn a living raising livestock. Eventually, they sold their land to developers. Not a single farm or ranch dating back to the 1800s has survived to the modern day. (Courtesy Moller family.)

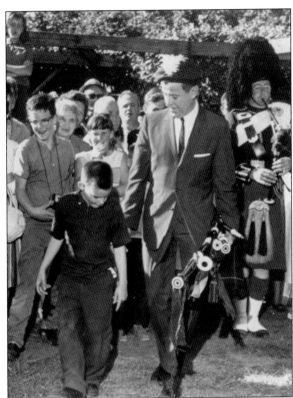

MUSEUM FUND-RAISER, C. 1973. With the widening of I-580 in the mid-1970s, Murray School was in danger of being demolished to make room for the construction. The people of Dublin once again rose to the challenge and developed a plan to move the entire structure to a new location next to St. Raymond's Church, though it would not be cheap. Museum fund-raisers, such as this one, were needed to raise the $30,000 required for the move.

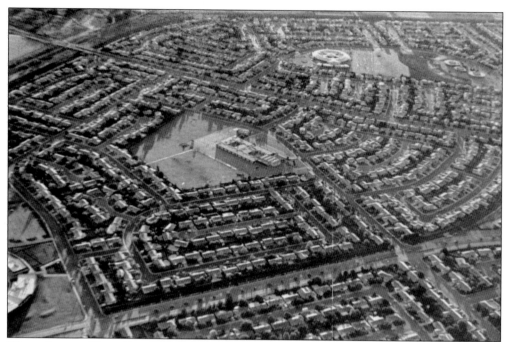

WELLS JUNIOR HIGH SCHOOL, C. 1972. This photograph taken of Wells Junior High School shows just how quickly Dublin had grown from a sleepy farming town in the early 1960s to a residential community in a few short years. Completed in 1971, the school helped meet the demand of a district already bursting at the seams. With all the hallmarks of a modern town, Dublin also boasted having such businesses as Bank of America, Transamerica Title Insurance, American Home Loan, Charlotte Cobb and Associates, Dublin Office Equipment, Diablo Personnel Agency, and Crown Chevrolet, just to name a few.

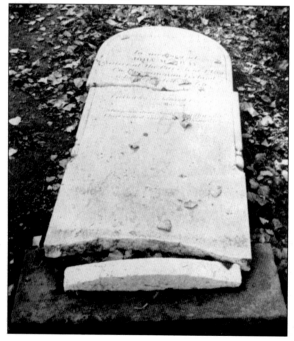

VANDALISM IN DUBLIN'S PIONEER CEMETERY, 1975. Vandals came into the Dublin Pioneer Cemetery behind St. Raymond's Church and caused almost irreparable damage to John Murray's headstone. Other graves in the cemetery suffered the same fate as well. (Courtesy Marie Cronin.)

DUBLIN PIONEER CEMETERY REPAIRS, 1975. Sometimes it takes an act of vandalism to let people know just how close they are to losing irreplaceable treasures from the past. Recognizing what was almost lost, people from the local area donated their time and materials to the restoration of the Dublin Pioneer Cemetery. Volunteers took great care trying to restore the tombstones to their original condition.

DOUGHERTY FAMILY PLOT. Since the 1880s, the Dougherty family plot has stood above every other tombstone in the Dublin Pioneer Cemetery. In an act of uncommon devotion, James Witt Dougherty even had his faithful dog Carlo buried there.

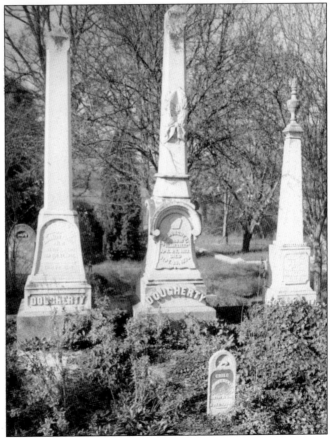

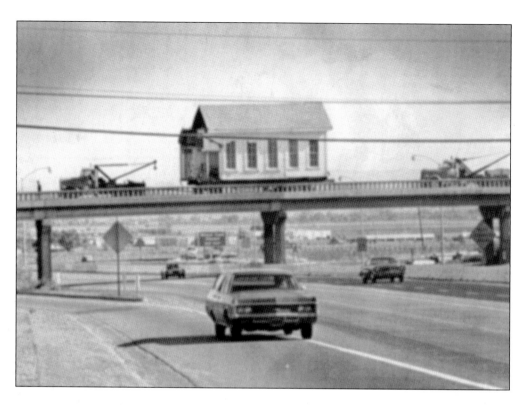

MURRAY SCHOOL MOVE, 1975. After almost 140 years of service to the community, the Dublin Historic Preservation Association transported the 80-ton schoolhouse to its new home. At a cost of $12,000, the move was no small undertaking, and workers carried out their duty with great care as the delicate structure lumbered over Interstate 580. Today it is located next to St. Raymond's Church and is used to educate the citizens of Dublin of their rich and varied past.

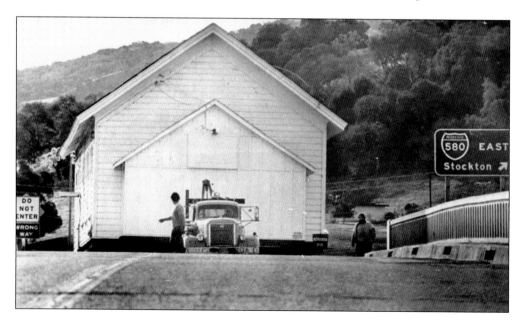

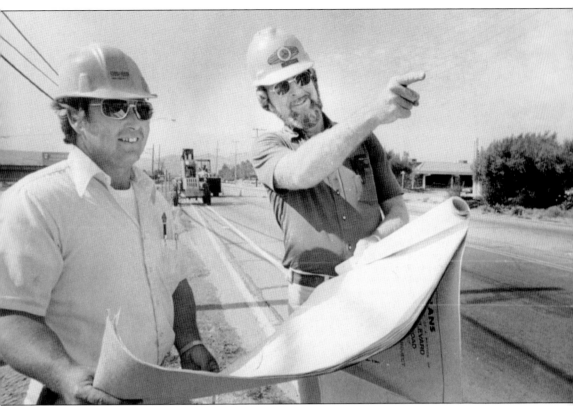

DUBLIN ROAD WIDENING, 1975. With an increase in the city's population since the early 1960s came an increase in traffic. This put a terrible burden on one-lane roads not designed to handle the daily load. Knowing the situation would only get worse with each passing year, government officials in the mid-1970s made millions of dollars available to improve the road system so it could handle traffic flows characteristic of a small city.

FREEWAY CONSTRUCTION, 1976. Much of modern-day I-580 follows the same route as Lincoln Highway, later Highway 50. In 1964, Route 50 was replaced with new numbers, including I-580 from Tracy to Oakland. In 1976, as this photograph shows, Interstate 680 was extended northeast along former California 21 to meet Interstate 80 in Fairfield. With the completion of the I-680 freeway between San Jose and Fairfield, California 21 was slowly decommissioned and the last vestiges of it removed by 1976.

FALLON HOUSE, 1976. This 1976 photograph shows the poor condition of the Fallon House, built in the early 1850s, another example of Dublin letting one of its treasures slip through its fingers. The years of damage and neglect were so extensive that the town of Dublin allowed the Pleasanton Fire Department to burn it down as a training exercise for its younger firefighters. If the fire department had scheduled their training just a week later, the Fallon House would still be here today. Plans had already been made to move it between Murray School and St. Raymond's Church, where it would have been preserved for future generations.

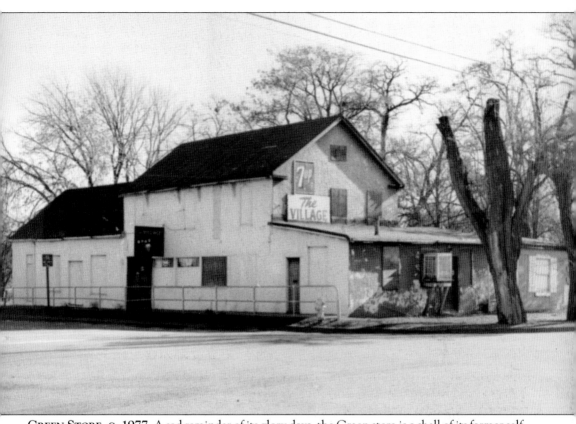

GREEN STORE, C. 1977. A sad reminder of its glory days, the Green store is a shell of its former self in this mid-1970s photograph. Known as the Village, the owners transformed the building into a bar and pool hall. In 1978, the saloon came under the ownership of a former local schoolteacher by the name of Virginia Madden, the wife of John Madden (who was the Oakland Raiders head coach at the time). In an ironic twist of fate, the old Green store changed hands once again and became the Church of Christ some years later.

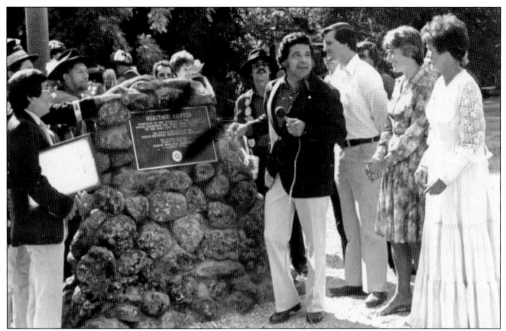

HERITAGE CENTER DEDICATION, 1977. After fighting the good fight for many years and spending more than $30,000 for transportation and renovation costs, this is a moment for Dublin to celebrate. On October 15, 1977, Floyd Mori, Charlie Santana, Valerie Raymond, and Marie Cronin officiated the dedication of the Dublin Heritage Center. In honor of the proceedings, members of the Joaquin Murietta Society, 13th Chapter, are dressed in traditional regalia. (Courtesy John Cronin.)

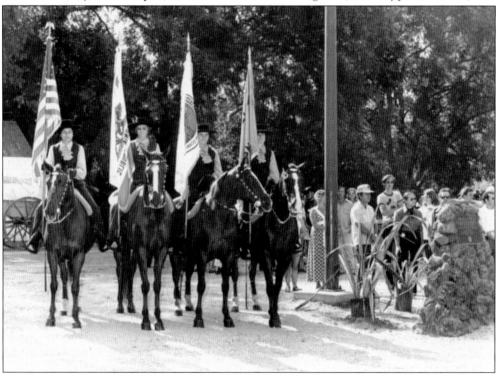

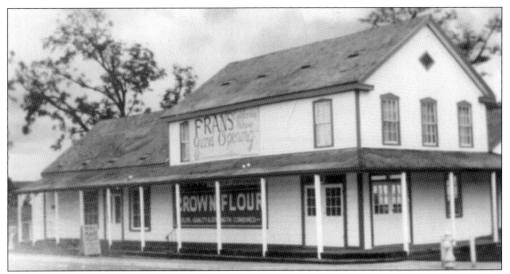

THE OLD GREEN STORE, 1980. In a rare example of someone rescuing a crumbling treasure from the past, after years of neglect, the owner of Fran's refurbished the old Green store to its original condition. They even had the Crown Flour advertisement restored, as seen in the 1906 photograph with George and Edwin Kolb on page 58.

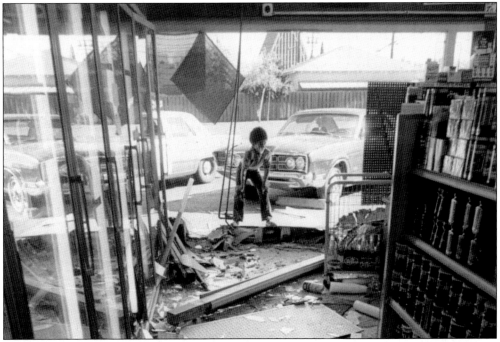

EARTHQUAKE, DUBLIN MARKET, 1980. As with many of the major earthquakes that have struck the Bay Area over the years, the one that hit on January 24, 1980, did so without warning. Registering 5.8 on the Richter scale, this major trembler occurred along the Greenville Fault and caused an estimated $11.5 million in property damage. Due in large part to the strict building codes enforced in an active earthquake zone, most of the damage consisted of falling bricks from chimneys, broken gas and water lines, broken windows, and mobile homes knocked off their foundations.

EARL ANTHONY, 1980. Considered by many to be the greatest bowler of all time, Earl Anthony won 41 PBA titles, 10 major bowling championships, 6 national PBA titles, 2 tournament of champions titles, and 2 ABC masters titles during his career. After he retired from the sport, Earl Anthony still had bowling in his blood. In 1980, he purchased a bowling alley from the Howard Johnson Motor Lodge. Renamed Earl Anthony's Dublin Bowl, he arranged to have ESPN cover a yearly bowling tournament from 1984 to 1992, the only nationally televised event in Dublin's history. After moving to Oregon in 1988, Earl Anthony returned to Dublin from time to time to host fund-raisers and charitable events for local causes. He died in 2001. (Courtesy Ted Hoffman.)

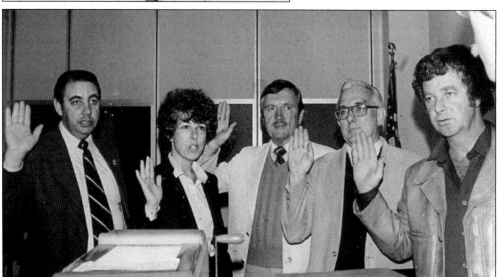

FIRST CITY COUNCIL, 1982. With their hands held high, the city council approves Ordinance No. 1, and Dublin is officially incorporated into a city. After 132 years of existence, beginning in 1850 when Michael Murray purchased a parcel of land from Jose Maria Amador, a simple vote of five established Dublin's rightful place as a city among cities in the Bay Area. Pictured from left to right are Peter Snyder (the first mayor), Linda Jeffrey, Dave Burton, Paul Moffatt, and Pete Hegarty. (Courtesy City of Dublin City Clerk's Office.)

DUBLIN INCORPORATED INTO A CITY, 1982. Since the 1960s, Dublin has taken active steps to shed its farming past and embrace urbanization. The journey has not been an easy one. A community 250 people strong exploded into 10,000 in the next 10 years. This meant thousands of new homes needed to be built, roads widened, additional firefighters and police officers hired, plus a myriad of other problems facing a growing population. No longer could the Alameda Board of Supervisors effectively manage a town like Dublin from a distance. Serious discussions about Dublin becoming a city at the governmental level started taking place in the 1960s, but after the people of the Dublin-San Ramon area voted against the town becoming a city in June 1967, the issue fell onto the back burner for the next 12 years. Another ballot measure came up in 1979 but was voted down again by the people of San Ramon. In November 1981, the same measure came up again. This time, the people from both towns voted to approve incorporation, and on February 1, 1982, after every member of the city council signed Ordinance No. 1, it became official. (Courtesy City of Dublin City Clerk's Office.)

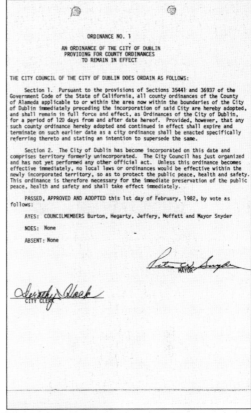

CITY MANAGER. From its incorporation in 1982, through the publication of this book in 2007, Richard Ambrose has served as Dublin's city manager. The rapidly expanding Tri-Valley area has become renowned as a place of prosperity, a center for internationally acclaimed business parks, and home to some of the world's largest corporations. The city of Dublin, located at the crossroads of the Tri-Valley, has contributed to the planned growth and forward thinking of the area.

SOURCES

Dougherty family collection
Dublin Heritage Center
Fallon family collection
Green family collection
Hansen family collection
Harvey family collection
Kolb family collection
Koopmann family collection
Martin family collection
Moller family collection
Murray family collection
Museum on Main Street, Pleasanton
Nielsen family collection
Reimers family collection
Terra family collection

INDEX

ACROSS AMERICA, PEOPLE ARE DISCOVERING
SOMETHING WONDERFUL. THEIR HERITAGE.

Arcadia Publishing is the leading local history publisher in the United States. With more than 3,000 titles in print and hundreds of new titles released every year, Arcadia has extensive specialized experience chronicling the history of communities and celebrating America's hidden stories, bringing to life the people, places, and events from the past. To discover the history of other communities across the nation, please visit:

www.arcadiapublishing.com

Customized search tools allow you to find regional history books about the town where you grew up, the cities where your friends and family live, the town where your parents met, or even that retirement spot you've been dreaming about.